PHOTOGRAPHING ASSIGNMENTS
ON LOCATION

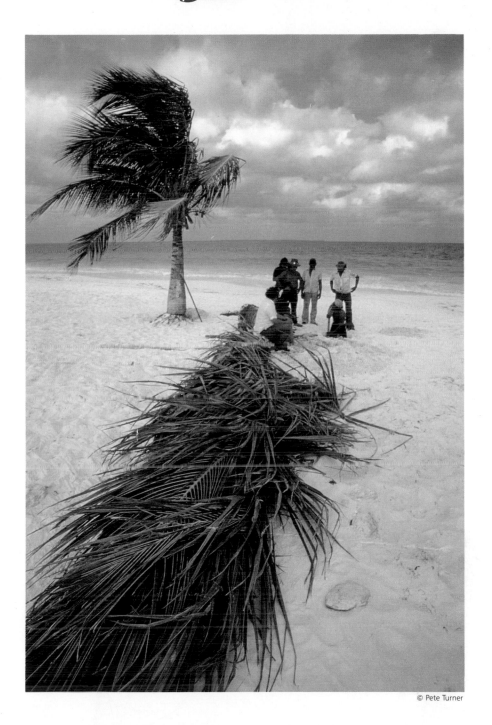

© Pete Turner

PHOTOGRAPHING ASSIGNMENTS
ON LOCATION

ADRIAN TAYLOR

AMPHOTO
an imprint of Watson-Guptill Publications/New York

TR
790
.T39
1987

Copyright © 1987 by Adrian Taylor

First published 1987 in New York by AMPHOTO,
an imprint of Watson-Guptill Publications,
a division of Billboard Publications, Inc.,
1515 Broadway, New York, NY 10036

Library of Congress Cataloging-in-Publication Data

Taylor, Adrian.
 Photographing assignments on location.

 Includes index.
 1. Travel photography. I. Title.
TR790.T39 1987 778.9'991 87-14440
ISBN 0-8174-5425-X
ISBN 0-8174-5426-8 (pbk.)

Manufactured in Japan

1 2 3 4 5 6 7 8 9/91 90 89 88 87

Editorial Concept by Marisa Bulzone
Edited by Robin Simmen
Designed by Jay Anning
Graphic Production by Hector Campbell

*To all the photographers who go on location and bring back the world,
and to all the editors and art directors who send them.*

Grateful thanks to Marisa Bulzone for editorial patience and understanding; to Barbara O'Reardon for transcribing inaudible tapes and illegible scrawls; to the American Express Company, *Travel & Leisure* magazine, and Magnum Photos, Inc. for their cooperation and permissions.

To the photographers in this book for opening their lives and files to me, my admiration and thanks.

To Frank Zachary for being a faithful guru and friend.

And to Chrissie, for love.

Contents

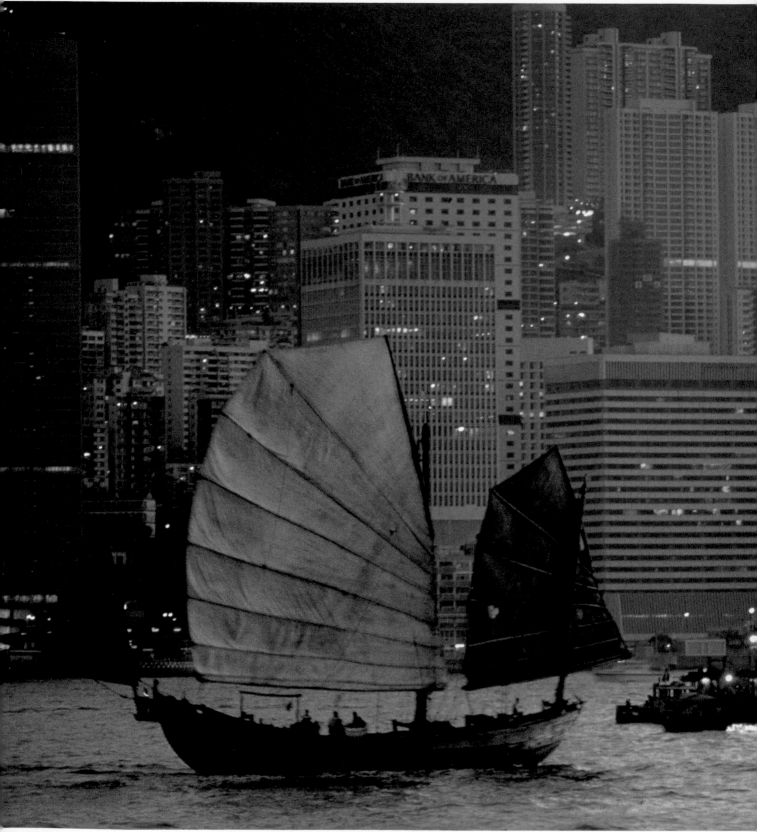

© Kelly/Mooney

INTRODUCTION

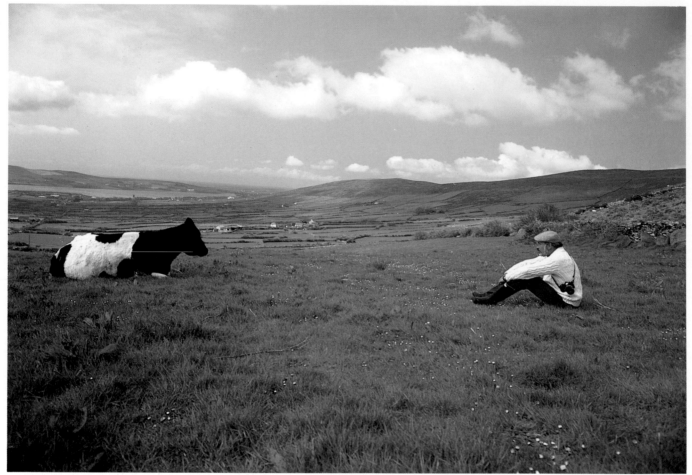

© Clem Taylor

This book is for aspiring professional photographers who don't mind traveling halfway around the world on a moment's notice and suffering jetlag, gastric acidity, exasperating customs agents, fickle weather, and temperamental equipment in order to have their photographs derided by editors, mutilated by art directors, rebuffed by clients, and ignored by readers. It happens.

There's another scenario: You arrive home and get the film back, do an edit, look at the snaps, know you've got it, and later see a double-page spread of *your* photographs with *your* name on it. This happens, too, but more rarely. If this book helps you make the latter happen more often than the former, then it will have done its job.

Location photography, in the widest sense, is any photography not done in a studio. Although travel photography is, by definition, location photography, location photography isn't necessarily travel photography. Travel photography should make the viewer want to travel. A photograph of a car on top of a mesa in Utah, for instance, is location photography. So is a picture of a fashion model in front of the New York Public Library. Photography is used in both these cases to sell a product. In travel photography, however, the place *is* the product.

Editorial, advertising, and news photography are different from each other only in the detail required and the way the pictures are used. Their aesthetics are (or should be) basically the same. Professional photographers' hopes of making engaging, lingering images are similar. The basic idea behind every good photograph is to plant a picture in the mind. Only some of the means and logistics for achieving this goal differ depending on the assignment's purpose.

This book assumes that you already know how to make a photograph. I hope that by reading about these successful professional location photographers' experiences and seeing some of their work, this book will help you make better photographs *on location*. Learning how other photographers solve their photographic problems far from home may help you solve yours.

My own involvement in location photography began professionally in the 1950s at *Holiday* magazine in Philadelphia, where I was hired as assistant to the art director, Frank Zachary. Almost immediately Zachary handed me a stack of photographs, color and black-and-white, and asked me to give him layouts for six pages. The story, as I recall, was about Yale University, a place I had never visited. (This was the first of many stories that I would edit and lay out about places I had never seen.)

An issue on Paris (for which I'd designed the cover) rankled particularly. I wanted very much to visit Paris and felt I could edit photographs of the city much better after some first-hand, on-the-spot research. I pleaded my cause but the answer was, "We want you to keep your freshness, kid." It was almost 25 years before I finally got there, and in between, I did several Paris layouts, as well as Europe, India, South America, Japan and a lot of other places that I'd come to know only visually, through photographs. I know now that the pictures I responded to then, intuitively, I would respond to just as excitedly now, although I still haven't been to some of those locations. There's an inevitability to a good photograph made on location, an inescapable sense of place that jumps right out at you. It rings true in the mind as it pleases the eye. It speaks, and sometimes it even sings.

Several career moves later, I drove across the United States with a Fujica camera. After 17 days—most of which seemed to be spent in Kansas and Nebraska—I arrived in San Francisco. Foote, Cone & Belding advertising agency had a temporary job for an art director. I took the job and for the first time became involved in directing location shoots. One of their accounts was Dorsett Marine, a manufacturer of fiberglass boats, for whom we shot a lot of locations. San Francisco Bay, Sausalito, the mothball fleet at Mare Island, Belvedere Lagoon, and even the sacred waters of the Crystal Springs reservoir were all sites we used for brochure and advertising photography. We even shot motion-picture film for a promotion.

It was an illuminating lesson—in logistics, selecting the right time of day, coordinating the models, the wardrobe, the boats and the client personnel to handle them—but most of all it was a valuable lesson in the care and feeding of a photographer. There's nothing like a week's location shoot to bring out the best (or the worst) in all concerned. I was lucky. The photographer was a perfectionist willing to experiment, the client wanted only our best, and the agency backed us up.

Later on at another agency, D'Arcy (now D'Arcy Masius Benton & Bowles), I worked on campaigns for the San Francisco Convention and Visitors' Bureau, American President Lines, Del Monte Lodge (now the Lodge at Pebble Beach), Lufthansa German Airlines, the Bermuda Tourist Board, and the Fairmont Hotel, among others. All of these accounts required location photography of one sort or another. All were for advertising.

Recently I spent ten-and-a-half years in the less gilded purlieus of editorial work as art director of *Travel & Leisure* magazine. This experience not only

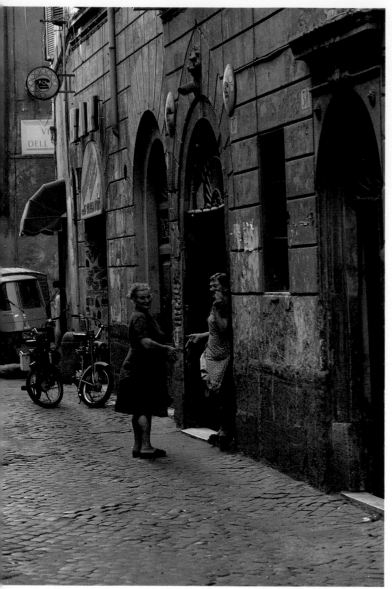

Backstreet, Rome, Italy

It's not without some trepidation that I include my own photographs here; the photographers represented in this book are heady company. My first photographic assignment was shooting Germany's Romantic Road in 1977 at the courageous suggestion of Travel & Leisure's *editor, Pamela Fiori (I still believe that it was a thinly disguised vacation). It was a rich experience of learning to travel, to see, and to record what I saw.*

Several assignments have come my way since then. They have all been enjoyable, and I have plunged into all of them with enthusiasm and gusto. I love to shoot on location, on assignment—and have come to know and love places I'd never have experienced any other way, or at least not the same way.

confirmed what I had already learned, but it added new dimensions to my understanding of the nature of travel photography. And *finally* I got to travel—to Paris, London, Rome, Venice, Ireland, Munich, Frankfurt, Central America, the Caribbean, Mexico, Canada, and to various sections of the United States. I also got to shoot some assignments on location. I've chosen to ignore a vague gnaw of guilt about denying a deserving freelancer the assignments I've covered. Rather, I feel the experience gave me resources to draw on when assigning others. I've learned that there's no substitute for *being there* and *shooting it*, for better or worse.

Magazine art directors and picture editors usually provide photographers with letters of introduction and assignment letters that detail the photo requirements involved before the photographers leave on assignment. Magazines will also make initial contacts for photographers in the destination country, book their airline and hotel reservations in advance, and initiate expense advances to them. But much of the "getting acquainted" process will be the photographer's own responsibility. And sometimes even getting on location will depend on the photographer's degree of ingenuity.

Photographers like to have their hands held. They are like children, at least the good ones are; that's why they're able to see as they do. Occasionally a photographer will call the art director from a remote region or strange city to relate some woeful occurrence—usually rain. Burt Glinn once called me from Bangkok to report that it looked more like Venice—flooded streets, monsoon-like rains, and water knee-deep in the hotel lobby. Acts of God and nature are bound to occur. You can only pray that they don't happen while *your* photographer is on *your* assignment.

It should be made explicitly clear in the assignment letter whether or not an assistant has been budgeted and approved for the trip. On some assignments assistants are essential. While some photographers will hire an assistant when they arrive at their destination, others have a network of assistants in various countries—invaluable for local contacts, customs, language and currency. In some countries guides are a prudent investment. A guide should, however, be hired only after securing his references and accreditation from a tourist office or other government agency.

The overall budget should be agreed upon *before* the assignment letter is written. A full breakdown of expenses should be given to the art director, art buyer, or picture editor, showing expenses in detail and the agreed-upon fee. Magazines usually send the photographer a contract spelling out such specifics as fee schedules, the use fees for secondary editions, and copyright ownership.

In addition to magazines, travel photography assignments are generated by government-sponsored tourist boards or bureaus (national, state, and local) and their advertising agencies. Other sources are hotels, resorts, airlines, cruise lines, restaurants, car rental and trans-

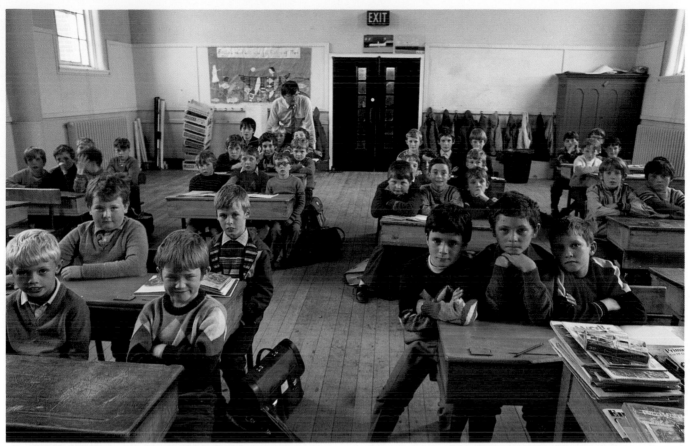

Classroom, Mallow, County Cork, Ireland

Magazines using travel/location photography:

Rates for magazine assignments vary, but here are some magazines that will provide their fee structure on request, although, of course, this information is subject to change.

Conde Nast's Traveler
Connoisseur
European Travel & Life
Gourmet
Life
M
National Geographic
National Geographic Traveler
Newsweek
San Francisco Sunday Examiner's Image
Smithsonian
The New York Sunday Times Magazine
Time
Town & Country
Travel & Leisure
W
Vis a Vis
Washington Post Sunday Magazine

Aktvell (Stockholm, Sweden)
Cambio (Madrid, Spain)
Capital (Italy)

Departures (London, England)
Epoca (Milan, Italy)
French Geo (Paris, France)
German Geo (Hamburg, W. Germany)
Illustre Suisse (Lausanne, Switzerland)
London Observer Magazine
London Sunday Times Magazine
Manchete (Brazil)
Merian (Hamburg, W. Germany)
Nieuwe Revu (Netherlands)
Panorama (Netherlands)
Paris Match (Paris, France)
Piacere (Italy)
Schweitzer Illustriete (Zurich, Switzerland)
Stern (Germany)

Inflights:
American Way
PanAm Clipper
SAS Scanarama
Swissair's Gazette
East/West Network (New York)

*Elizabeth and John Kiley at Dromoland Castle,
County Clare, Ireland*

*The bed from which Heathcliff (Sir
Laurence Olivier) lifted Kathy
(Merle Oberon) in the film,
"Wuthering Heights," Old Milano
House, Gualala, California*

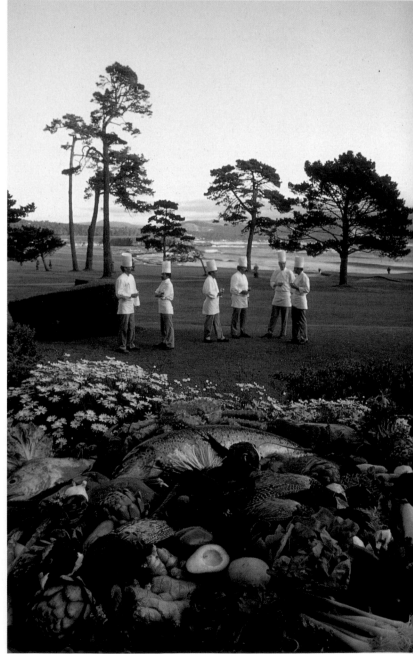

*Chefs at The Lodge,
Pebble Beach, California*

portation companies (like Simplon Orient Express), worldwide financial institutions, and the advertising and public relations agencies for each of the above.

Corporate annual reports are still another source of work that many top travel/location photographers have found lucrative. Annual reports are a subspecies of travel/location photography, often requiring endless patience in corralling peripatetic corporate heavies and getting them to places they might not ordinarily be found in, to be photographed with people they might not ordinarily mingle with, and to adopt attitudes they might not ordinarily be comfortable conveying. Then there's the plant, the products, and the mystique of the company that have to be rendered on film. (Burt Glinn always tries to photograph corporate executives in their natural habitats, where they feel comfortable and he has more control of the situation.)

Annual reports have become a sophisticated medium of corporate communication, reflecting a company's philosophy, taste, style, goals, and achievements, including the bottom line. Many are produced by world-class designers, the results often stunning in graphic conception and execution. It is no longer enough to show a picture of "the factory" and "our founder." The photographic possibilities and renditions today are often at an extraordinarily high level of quality.

These are some of the design firms and individuals who produce some of the best annual reports extant:

New York
Anspach Grossman Portugal
Bruce Blackburn and Associates
Chermayeff & Geismar Associates
Corporate Annual Reports (Les Segal)
Richard Danne and Associates
Jack Hough
Arnold Saks Associates

Bicoastal
Landor Associates (San Francisco)
Pentagram Design:
Peter Harrison and Colin Forbes (New York)
Jonson, Pedersen, Hinrichs and Shakery Inc. (Connecticut, New York City, San Francisco)

Chicago
Crosby Associates (Bart Crosby)

The photographic prices for annual reports are usually based on a *day rate*, which varies, depending on the mystique of the photographer, from $750 to $2,500 per day.

Despite the foregoing, there is a trend nowadays to scale down annual reports, at least in style, to a leaner look. There is less ostentation, less glitz. The taste level is still high, but the big, *big* budget annual reports are less *de rigueur*. There are more stock images used now in annual reports than there were previously. These are usually budgeted by print run: General Motors pays

Bed and Breakfast Inn, Navarro Ridge, California

more per stock photo used than Ralph's Pretty Good Groceries because they run more copies.

Before the photographer goes on assignment it is simply basic good sense for the photographer and the art director to get to know each other.

The photographer needs a bit of an idea about the designer's style beyond the purely visual, and vice versa. There are hints, clues, and directions to be gleaned from face-to-face meetings that never seem to find their way into assignment letters. The reaction of an art director to a photographer's portfolio can speak volumes. (There are art directors as inscrutable as the sphinx, and photographers too.)

In general I look for the photographer for whom a specific assignment seems custom-made, whose previous body of work fits the idea of the story, and who is stirringly motivated (for example, Burt Glinn on Japan or Anthony Blake on food in Paris). An affinity for a place, if not a deep love for it, is something that usually shows on film.

Occasionally I like to go exactly the other way and assign a photographer who has never done a story like the one at hand. This cutting across the grain can achieve an unexpected, fresh point of view (for example, assigning Kelly and Mooney to shoot Disneyworld). The latter course can be risky, more so if a free exchange of communication is lacking.

Most good location shooters love a challenge, a new kind of assignment that breaks them out of their typecasting. Often that's when they'll play over their heads and bring back really unusual, sometimes spectacular photographs. (It has always seemed an exciting fantasy to assign Richard Avedon, for instance, to photograph Leningrad; Hiroshi Hamaya to shoot New York City; Bert Stern to do Denver; Snowden to cover New Guinea or Indonesia. The mind reels in anticipation of the results of such assignments.)

There have been times when I've had second

thoughts about an assignment, when the photographer just didn't seem to light up enough at the prospect of shooting a subject—and the assignment had already been offered. Some photographers will turn down assignments that they feel aren't suitable, but everyone wants the assignments that are "plums": a travel shoot in Paris, London, Venice or San Francisco; an Exxon Annual Report; a Mercedes Benz 100th Anniversary book, or the opportunity to illustrate "A Taste of Bordeaux."

Then there are the more usual assignments, no less important for their lack of glamour, but not quite guaranteed to quicken the pulse. These are the assignments that offer the opportunities to show you're a cut above the others—that when you're presented with a lemon, you can come back with lemonade, and a smashingly good lemonade at that. Shooting a featureless new hostelry, all blank facades and uninspired design, no matter how costly or allegedly chic it may be, is the kind of challenge that requires digging deep for fresh solutions.

It's precisely this digging for (and *finding*) new approaches and fresh ways of seeing the cliché that makes a good photographer become invaluable. On any assignment, whether it's a star turn or a rent-payer, the creative requirements are the same: Bring home pho-tographs that are better than expected, meet the stated needs and go even further, elicit gasps of delight from the client and make the jaded art director smile.

Then there are the impossible jobs: The assignment you know probably can't be done. If you're brave enough to take the job, you'd better either pray you'll wake up tomorrow as Peter Turner or figure out a way to turn the job into something you *can* achieve. Talk to the picture editor or the art director, talk to the editor or the writer of the piece. Look for the hook, the handle, the bit of short circuitry that brings the job around to the realm of the possible, maybe even into the realm of the wonderful. Work it out on paper. Sit down and *think*. Work out the possibilities—there are usually more than immediately meet the eye. Work out the expenses, too.

The photographers in this book have done these things, more than once. They all bring back the story, cover all the bases, and take calculated risks. They all have that in common. And this too: A down-to-earth, real life approach to creating *fantasies*, constructing moods, filling pages with enough energy to make people buy, or go, or simply wonder. It's my earnest hope that when you've finished this book, you'll have a clearer understanding of what location photography is, and how great location photography is created.

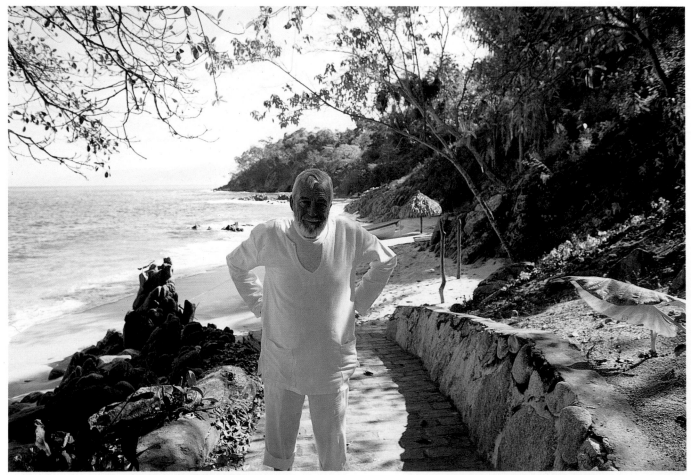

John Huston, south of Puerto Vallarta, Mexico

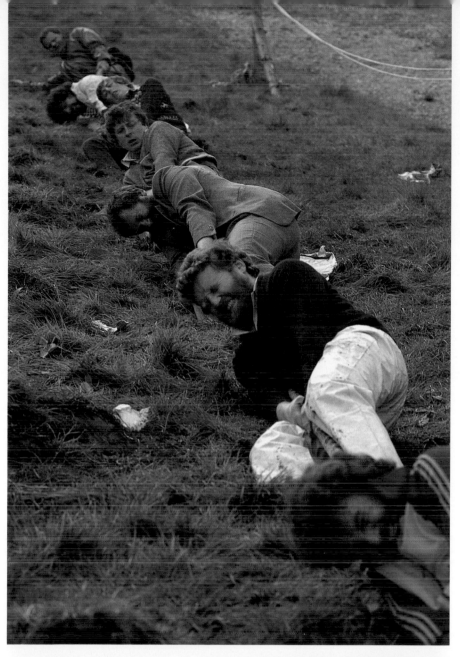

Espenet, wood craftsman,
Bolinas, California

Tug of war,
County Kerry, Ireland

At the cattle market,
Mallow, County Cork, Ireland

15

BUILDING
A PORTFOLIO

I've known Tom Kelly and Gail Mooney since the summer of 1976 when they arrived in my office at *Travel & Leisure* seeking an assignment. Their portfolio was much like other portfolios I'd seen by newly graduated students, but with something extra: They had a certain maturity of outlook, not just photographically as yet, but toward the world in general.

I got the feeling they'd been around, could cope with situations and get the pictures. Tom seemed very competent technically. Gail was more visually adventuresome and a bit feisty in a refreshing, offhand way.

Their portfolio contained amazingly few photographs made at the Brooks Institute where they'd received their degrees. There were many more pictures made in Southeast Asia by Tom, and a lot made by Gail all over the world, the best of which she shot on a hippie-style odyssey through Europe, Afghanistan, and the Middle East. These personal photographs were the basis of their beginning portfolio.

In 1977 they married and traveled to Europe on a honeymoon not recommended for your average newlyweds. The entire trip was scheduled around optimum shooting times at points on their itinerary. Camping out in a tent helped solve some of the logistics. They could sleep on location to get first light if that was what was called for, or they could drive all night to arrive, gritty-eyed, at their carefully chosen site.

The result of this grueling, month-long shooting spree was a portfolio of range and freshness. For a travel magazine art director, they were a gift from heaven. Their love of travel showed in this first large take, which was totally self-assigned and self-motivated. The fact that many of these photographs are still purchased from their stock is eloquent testimony to the staying power of the images.

Building a portfolio is a crapshoot, a very dicey business. If you have strong inclinations to be a certain kind of photographer, your portfolio should show this. Most of all, it's the quality of the work itself that counts, in whatever form it's presented.

My personal preference is to see a carousel tray of 80 transparencies maximum, carefully selected, tightly edited, and sequenced for maximum visual and emotional effect. I never object to seeing large format transparencies, or even prints, neatly presented. I do not like a lot of loose tear sheets, but I greatly dislike mounted, matted prints that are *signed*.

Ultimately, it's the development of something personally felt and transmitted in your work that will bring you the most nourishment and reward. That development will take time, and what it will take, most of all, is shooting every day, not prodigally, but with some inner discipline that will let you know when you've done it well. Equally important is bringing a brutally honest appraisal to your work when it has not been done so well.

I think that may sum up the professional credo and the aesthetic rationale of Tom Kelly and Gail Mooney. They have their own heroes, of course, and some of them will be found elsewhere in this book.

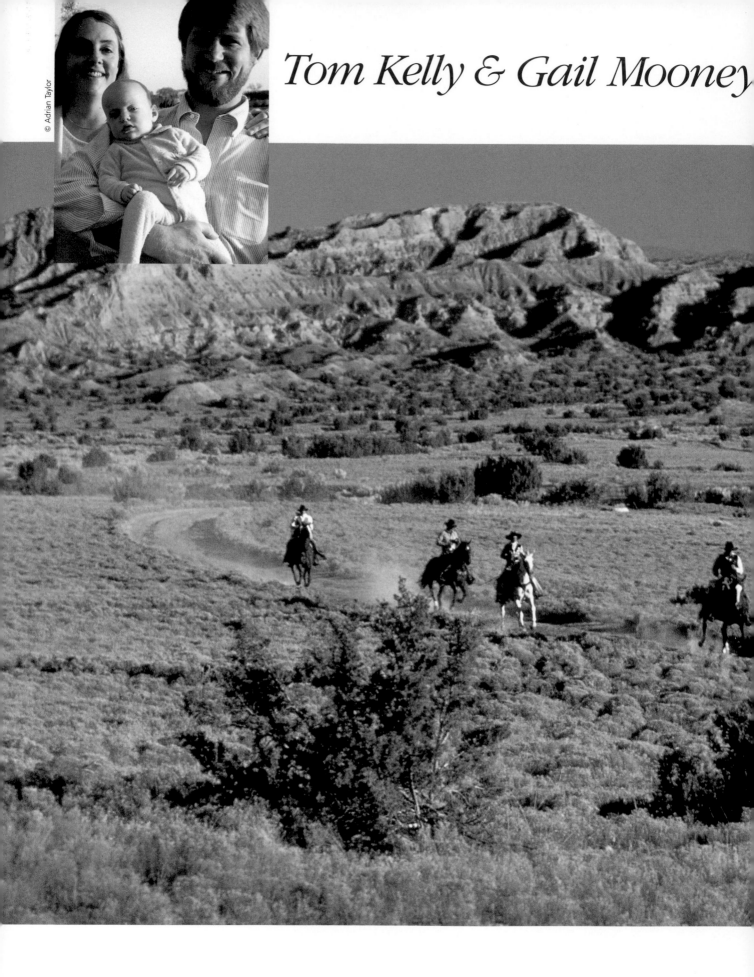

© Adrian Taylor

Tom Kelly & Gail Mooney

Gail Ann Mooney was born in Chicago in 1951 and lived with her family (including two brothers and a sister) in Rochester and White Plains, New York and in northern New Jersey. She attended Syracuse University for two years. Then in 1971 she was swept away on the cresting wave of young people circling the globe on backpacking odysseys. It was on this journey that she discovered her passionate commitment to photography.

When she came home, her newfound career goals led her to Santa Barbara's Brooks Institute of Photography. In 1973, she met fellow student Tom Kelly, her future professional partner, husband, and father of their daughter, Erin.

Thomas Allen Kelly was born in Doylestown, Pennsylvania in 1950 and attended Doylestown public schools where his interest in photography began. From 1968 to 1972 his Air Force service took him to South Carolina, Kansas, Brazil, and Thailand; it also allowed him to pursue some of the more technical aspects of his career choice—processing reconnaissance film—and to shoot some exotic locations.

Shortly after the end of his tour, he enrolled at Brooks Institute and met Gail. They live in a large, handsome Victorian house in northern New Jersey with their daughter, and they are co-owners of, among other things, a computerized stock file.

We met as students at the Brooks Institute of Photography in 1973. It was very much a do-it-yourself, on-the-job, learn-the-hard-way type of school. We really didn't know which direction we wanted to take, but we did know that we weren't interested in spending the rest of our lives in a studio. We both decided to take a commercial photography major, which meant that you actually minored in everything. This turned out to be a good choice, because today we shoot a little bit of everything—industrial, corporate, advertising, and editorial.

People starting out always ask us, "Should I go to school?" We never quite know what to say to them. Looking back, we agree that our school experience taught us mainly to see and control light. It gave us the technical knowledge to get our message across. We were also taught a lot about professional presentation, which is so important when you actually start dealing with clients.

Shortly after graduating, Gail visited Jay Maisel at his studio in New York City. She had two portfolios: One from school, which featured a lot of table-top still life, and a second consisting of travel shots that she had taken before going to Brooks.

When Maisel saw the school portfolio, he very bluntly said: "Is this what you want to do? This doesn't look like what you want to do—this is garbage." Gail replied, "No, I don't really want to do this, but everybody tells me that you've got to get a studio because that's the way to make money. I'd really like to be doing this (and showed him the travel portfolio), but everyone says there's no money in it." Maisel looked at the pictures and said, "These are great. How old are you?" In response to Gail's reply, Maisel declared, "Twenty-four years old and you're already making compromises." From that point on, we've stuck with travel photography.

We decided to get married in 1977. One of our relatives suggested a refrigerator as a gift, but we requested money instead. We used the gift to travel to Europe for a month, figuring that one or two of the pictures would finance the cost of the refrigerator. And it worked.

We used our honeymoon/shooting trip to build our portfolio—that is, our first real portfolio for travel work, which we both wanted to pursue. And we're still selling some of those pictures today, which is amazing considering they were taken in 1977.

When we returned, *Travel & Leisure*, for which we'd done some previous work, did a special advertising section on Europe. In the end it consisted almost exclusively of our work, which really got us rolling. We got a lot of jobs after that—of all different kinds. We took anything that came along for the experience.

Then, in 1978, we traveled to Europe again on a self-assigned stock shooting trip, this time to Britain and Ireland. It was terrific. We were finally on our own and knew that we could make it work. The light in the British Isles works well with Kodachrome, and we took a lot of great shots. There were no pressures, no stress of having to perform or deliver. With our naive overconfidence, we thought we could do just about anything, which was good because we weren't afraid to try for a shot. Anything we shot was something we really wanted to shoot—that's probably why some of these photographs are still our favorites, still part of our portfolio, and people still react to them.

Taking chances usually comes first in this type of photography, although early in our career we were more cautious. Every situation was a big deal then. Today the same type of thing isn't as intimidating. We can walk into a place cold now and not knowing anything about it we can size it up and shoot it. If it's an intimidating situation, such as photographing a famous person, we think about it a lot beforehand. But we can just as easily walk into it cold and size it up on the spot. We decide we're going to do it like this, ask ourselves will it work, won't it, and we'll go back and forth a few times.

When we returned to the States we settled in New Jersey, and we've never regretted not opting for a studio in New York. In that way, we were able to invest a lot more money in our business.

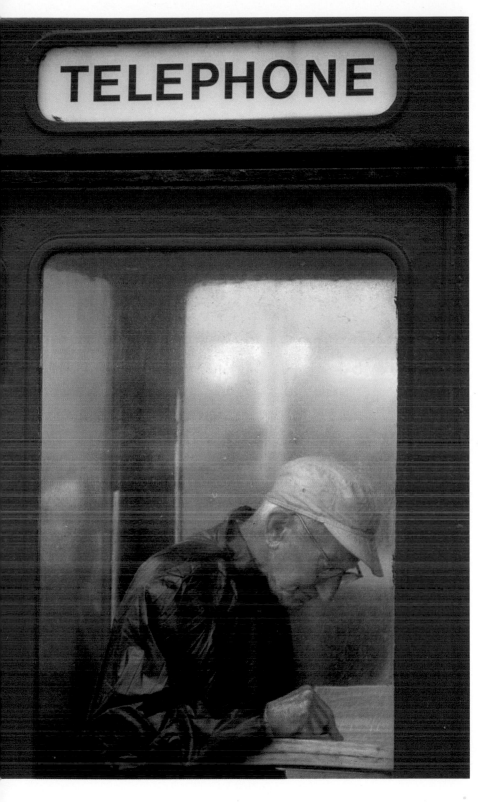

TELEPHONE

This is one of our favorite pictures from our self-assigned stock shoot in Britain. It was taken in Blackpool, England. We're not sure which of us actually noticed him first and then grabbed the camera and started shooting, but it didn't matter because the man just stood there for about 20 minutes with his finger on a line in the phone book.

It was a rainy and windy day, and the glass in the phone booth was misted up so that we were shooting as if through a diffusion material. This gave the whole picture a nice effect—the red of the phone booth just glowed, in contrast to the man's black slicker and white cap.

We'd assign ourselves shoots on weekends. If there was something happening in New York City, we'd pop into town for the day. We'd drop by street festivals or anywhere there might be something happening—there are pictures to be taken everywhere. We were shooting for stock, and the stock agencies we interviewed with wanted large quantities of slides. So we'd shoot anything that came along—and it was great training.

At one point we decided to take fun pictures, and did an entire series on the Jersey shore. Each weekend for an entire summer we'd go to a different town along the coast. We kept at it until we'd covered it all. A lot of that work was sold to *New Jersey Monthly*, and after that we started getting assignments for the "I Love New York" campaign. They sent us on about four or five trips.

But our first major location assignment was to cover the Chesapeake Eastern Shore for *Travel & Leisure*. The weather was perfect the entire time we were there, which was, of course, a blessing. We didn't do any arranging of photographs, except for one shot of James Michener. All the rest of the shooting was spontaneous.

The amount of preplanning we do depends on the assignment. One thing we always do is try to arrange our schedule to be in a place when interesting things are happening. We do this even on self-assigned stock trips. We try to coordinate as many activities as possible in an area, within the time of our stay.

Of course, most of the time when you're on assignment, you're working from a shooting list. But if we're told to photograph a specific place, we try to go out of our way to photograph it the way we see and feel it. We try to fulfill an assignment in our own way and through our own experiences.

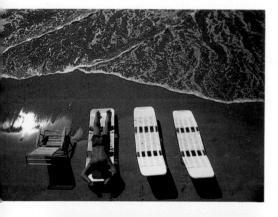

The Jersey shore in summer is where it all hangs out, however incongruously.

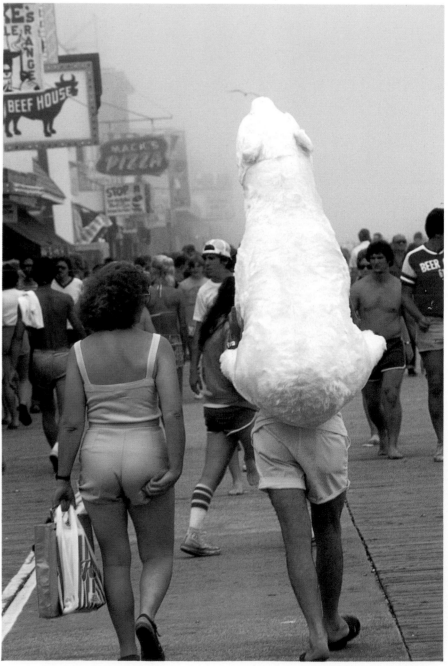

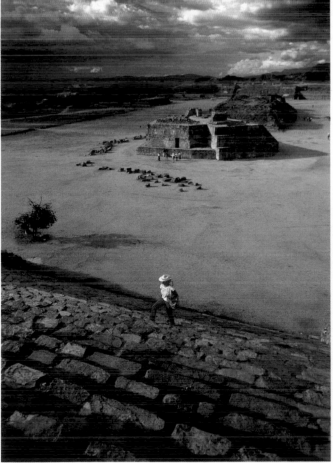

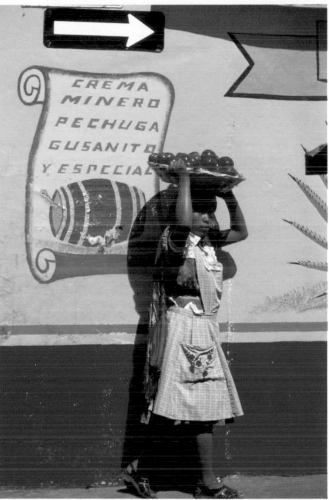

*We went to Mexico in 1985–86,
assigned by Hill & Knowlton, a public
relations firm, to make photographs
for the Mexico Ministry of Tourism.
After seeing the pictures from that
shoot, including this shot of Mayan
ruins at Monte Alban,* Travel &
Leisure *gave us a story to shoot on
Oaxaca, Mexico, which appeared in
the March 1986 issue.*

Ideally, you have a couple of days just to feel out an area and not shoot. (Of course, you always have your camera with you just in case something interesting happens.) But this gives you a chance to meet the people and eat the food. Unfortunately, most travel assignments don't carry a lot of time, so you have to make arrangements beforehand, and that's a pity. In such cases, it's pretty hard not to look at what's been done before and pick up on other people's reactions to a place. If you're given ten days to do an assignment, you've got to come up with certain angles on that area—certain specific things that other photographers have done before. We might not see it in the same way, but we pick up on the angle. You try as hard as you can to come up with something different, but you've got to move on because you know that while the weather is perfect today, it more than likely won't be tomorrow.

This is especially true when you're assigned to photograph major cities. We worked very hard on the San Francisco assignment for *Travel & Leisure*—we must have spent as much time in planning as we did on location. We spent hours on the phone, making arrangements with everyone from the Convention and Visitor's Bureau to the press liaison for Mayor Dianne Feinstein. But even though it's a much-photographed city, we tried to come up with one real "grabber." For the San Francisco shoot, it was the moon hanging over the city.

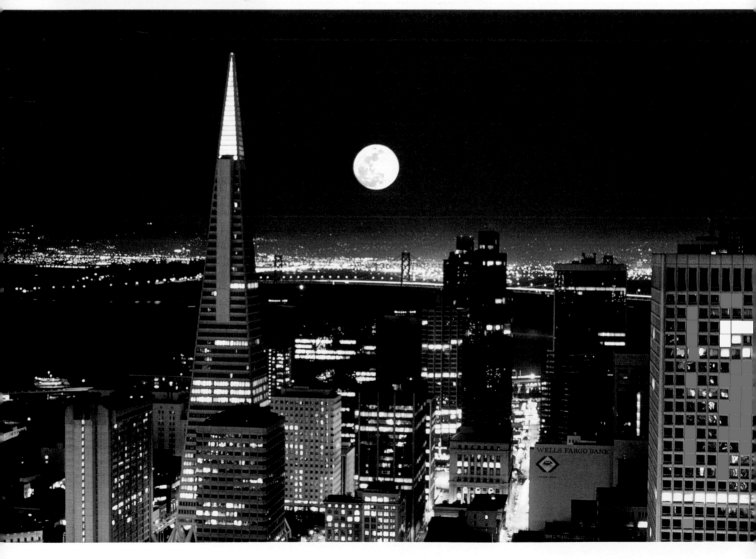

In contrast, when we were assigned Bucks County, Pennsylvania, which is where Tom's hometown is located, it was a very rewarding experience, because we already had the "feel" of the place down pat. We discovered a lot more than we'd ever seen before by having to look for it and then photograph it.

There's not a travel magazine around that's not going to ask you to shoot clichés. You can't avoid them. They may not come right out and ask you to take a cliché, but they expect them—because the readers expect them. However, that doesn't mean you have to shoot it as a cliché—it should be shot in a surprising manner. The subject matter may be a cliché, but you approach it on your own level. You study what's been done and try not to repeat it, by working at a different time of day, for instance, or perhaps in a different type of weather, or from a different angle, or with different light. You take everything that's working for you with the picture and push it. And you don't just do it once—you do it several times.

There are times when you shoot and you think it's garbage, but you go for it—nothing ventured, nothing gained. The little girl on the road with the sheep is a perfect example. We walked away from that shot thinking it was a totally cornball idea. Can you imagine anything more clichéd than a little kid in a straw hat on a road with sheep? But it worked because it had that quintessential Bucks County feeling.

This is one of those perfect moments that you can't anticipate. They just happen sometimes, and you're glad you have your camera ready when they do.

We were photographing Bucks County, barreling down Mechanicsville Road in the van, and this family was having a birthday party in the front yard. There must have been 30 people on the lawn with picnic tables in front of a red barn. They were just standing there looking across the lawn at us, and we leaned out the window and took the picture, then waved and drove off. If we'd have gotten out of the van before taking the picture, the moment would have been gone, and so would the picture.

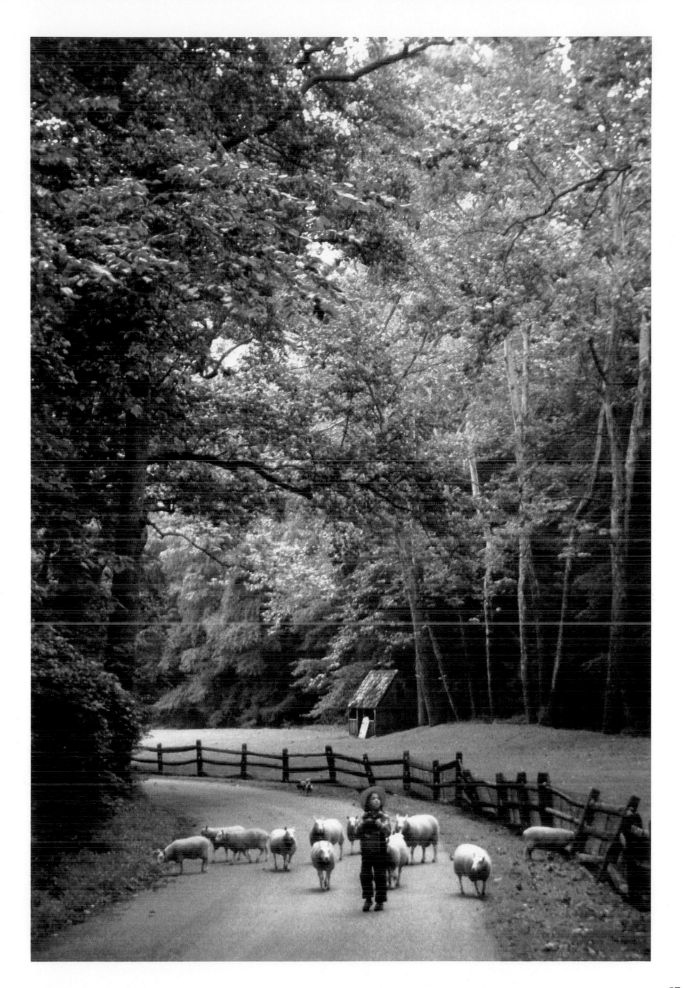

When you're working for a travel magazine, you're given a list of specific people or places to be photographed, whether it be a local celebrity or a special restaurant. A lot of times there will also be a specific slant—the art director and the editors will try to define the style that the magazine is trying to bring out in a place. We use that as a guideline. Sometimes there is a comparison to another photographer, maybe John Lewis Stage, who is very influential in the field. We admire and have studied his work a great deal—Stage is a master of the posed portrait. Previous to studying Stage's environmental portraits, we would photograph people strictly as candids. Now we try to visualize them first in certain settings.

When you're photographing people on assignment, you've got to be able to relate to them. Gail can talk to anybody about anything, which is a real gift, but sometimes we'll do research on the subject if we want to know what we're going to talk about.

People who are photographed

again and again don't necessarily need to relate to the camera. Why should they bother? They're doing you a favor, but they don't always want to do it. If they don't relate to you as a person, it's going to show in the final photograph.

We learn from other photographers just as we compete against them for jobs. By the same token, we learn from ourselves as time goes on, and we compete against ourselves, trying to surpass previous work. This comes out mostly in our editing—you've got to be ruthless in editing your own work, because if you're not ruthless with yourself, somebody else is going to be ruthless with you. We always edit the take before we send it on to the editor or art director. Besides those pictures that capture the "moment," the ones that are chosen for the final submissions fulfill our own needs in terms of the reasons why we took them. If you don't want to see your name on the shot when it appears in the magazine, you don't show it to the editors in the first place.

Gail recently did a feature on Martha's Vineyard and Nantucket islands for *National Geographic Traveler*. The assignment was to show the contrasts between the two islands, which is really more of a feeling than a visual statement. Sometimes you'll have a problem when an editor or writer has been to a place before you and makes specific suggestions for photographs. You get there and you look at it and think to yourself, "There's no picture here." What they've reacted to is a feeling or experience that they had—they were sitting on a balcony and the sun was setting and they were enjoying a good bottle of wine. You can't go back and recapture their experience. But that's why we *make* pictures, we don't "take" them. That's an overused expression, but sometimes you can't make everything look great; some things just don't come off. We try to illustrate a place by figuring out what is best said about it visually. We find out the fine points about an area, and then set out to illustrate them, not just wait to capture them.

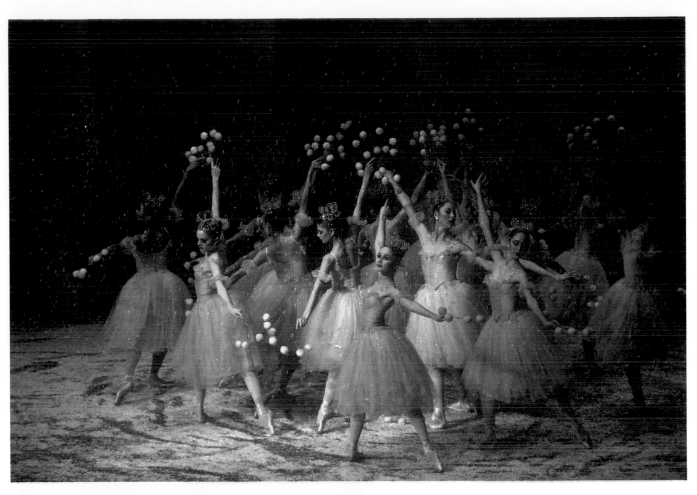

We were photographing an assignment on Christmas day in New York, and had to photograph the Nutcracker Suite *ballet*. We had set up with tripods and had shot a couple of rolls when paying customers started complaining. We were being kicked out just as we were getting started.

The public relations ladies were literally standing behind us, yelling "Hurry up, you've got to get out of here," when we picked up the cameras and took this shot, hand held. We had no choice. They were tugging at our sleeves to get us out the door, but when you need the shot, you've just got to do it — no matter what it takes.

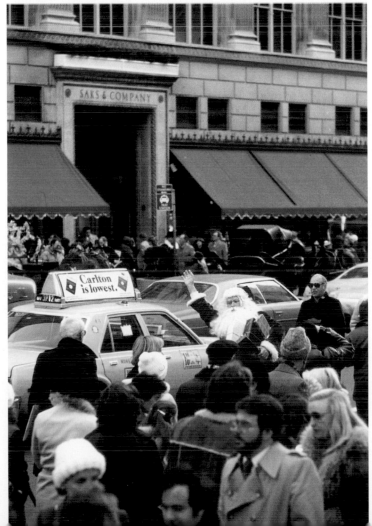

Tis the season when not even Mr. Kringle can get a taxi on Fifth Avenue in New York City. (The shot was set up but is nonetheless accurate.)

Many times on location, you're assigned to shoot in specific places, such as Radio City Music Hall, the Metropolitan Opera, or Carnegie Hall. In cases such as these, you call ahead and ask what the restraints are. Is there a union? Do I have to hire someone to plug in my lights? If that's the case, then you have to decide whether the budget can afford it. On an editorial shoot, this is usually not the case. So you have to plan how you're going to get around that situation in advance.

We've found that a little sweet talk can go a long way. If you can find the right person and establish rapport on a one-to-one basis without all the politics and territorial imperatives, you can get a lot farther. Sometimes you have to resort to not asking, just playing innocent and hoping that you don't get caught. Of course, that's not usually the best policy, because you're leaving a lot to chance. Always be prepared with your battery flash.

Our minimum equipment for travel would be two camera bodies, a 24mm lens, a 50mm lens, and an 80–200mm zoom lens. But most of the time we travel fairly heavy. If you're doing corporate work you need a lot more lenses, because the client may ask you to do anything from an executive portrait to an aerial shot. Sometimes when you're walking into a situation cold, you bring extra equipment, such as electronic strobes, because you don't know what to expect, and you want to be prepared for anything. We use Dynalite strobes on locations where we know we can plug in the power packs; otherwise, we use battery-powered Norman strobes. On some jobs, we'll bring both.

But equipment is just a means to an end for us. So many times you'll hear a photographer say that he walked through fire to get a shot, and then you look at the final photograph and say, "So what?" Our photography depends much more on finding the right moment and being able to capture it.

Of course, there are those times when you are going to get lucky; you pray for them. Those are going to be your most memorable moments and the times when you will possibly produce your finest pictures. If you can plan to be in a place when the ultimate is going to happen, and catch the event at the right time of day—that's *control*.

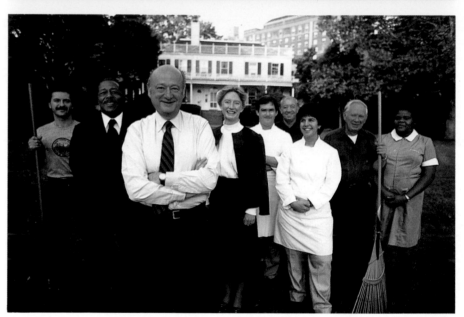

Our assignment was to photograph "New York is an Island," and while there were certain specific things we had to do, we had a lot of free rein. We had to shoot certain things, such as the Circle Line boat tour and Gracie Mansion, but the rest was up to us.

At first we thought of photographing Gracie Mansion as a house that overlooked the East River, but then we got the idea of photographing the staff.

We hadn't intended to have Mayor Ed Koch in the picture, but when the PR person from the mansion called to confirm the date and time of the shoot, she told us that the Mayor would be there at 7:00 AM. What could we say?

We arrived at 6:30 AM and set up for the shot. The plan was to have the

mayor seated, with his staff behind him looking very intimidated. Koch had lost the primary election for Governor of New York the night before, and he arrived in a miserable mood. We asked him to sit down and he said, "I'm not going to sit there. I don't want to look like some old duke." That was it—we had to change the whole concept on the spot.

This made us angry, especially when he just stood there frowning at the camera. "Come on, Mr. Mayor, smile," we said. "I don't smile," he replied. The whole shoot was dying right in front of our eyes. "Well, just smirk, then." That did the trick. The mayor cracked up and everybody laughed. Again, it was only a moment, but that was the photograph we were looking for.

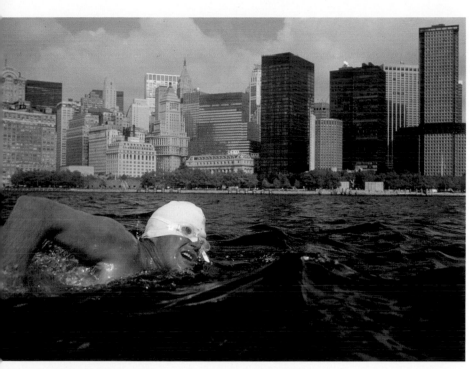

This shot was taken for the same assignment. We were on board the Queen Elizabeth II, *coming into New York harbor,* and the ship was being held up because there were swimmers in the water. We hollered over the edge: "Are you crazy?" and they replied that it was a marathon swim around Manhattan.

So we followed that thought—we wanted to photograph one of the swimmers against the skyline. We rented a little lobster boat and borrowed a 600mm lens from Nikon. We were shooting from very low in the water by the South Street Seaport, when suddenly the boat started taking on water. There we were, sinking in the middle of New York harbor, with $20,000 worth of equipment on board. We managed to get back to shore just in time, and luckily we had gotten the shot, so it was all worth it.

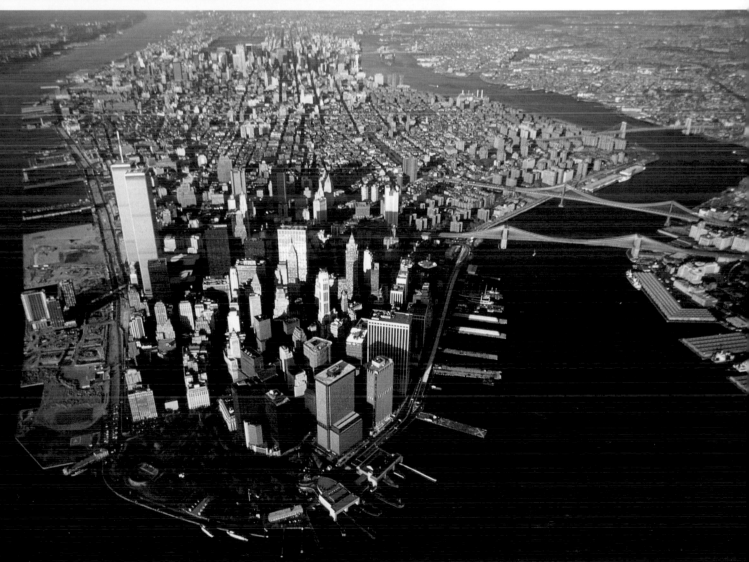

REGIONAL
COVERAGE

He's really only one person. But John Lewis Stage's photographs for *Town & Country* are often very different from the ones he does for *Travel & Leisure* or those he did previously for *Holiday* magazine.

Throughout his long career Stage has managed to change gears not only in relation to the style of the magazine he's shooting for, but also in relation to the subject at hand. He constantly "tunes in" to his subject with great acuity.

His scenics seem just right no matter how surprising his point-of-view may be; his portrait subjects always seem to be at ease, comfortable, and positioned in the exact place within the frame that evokes the most character of person and location. And it all looks so *right*, so natural and unforced. A study of Stage's work over many years for various magazines reveals that the elements of his style have been remarkably consistent but never boring.

Travel & Leisure is basically a glamorous "how-to" book of travel facts and ruminations combined with handsome photographs of places. Maintaining control of the subject matter requires homework, legwork, patience, persistence and mastery of the photographic medium, all hallmarks of Stage's style of photography.

Stage's work in *Town & Country* magazine bears his distinctive stamp, but it also is imbued with the gloss and chic of the *haut monde* environments and subjects *Town & Country* thrives on. The *rightness* and naturalness are still there, but it's a different kind of subject, and more to the point, a different, more sophisticated audience.

Success in Stage's location photography comes, most importantly, from his ability to communicate with the art director. Stage pre-visualizes layouts as they might eventually appear. He sees photographs in the context of the final printed page, and shoots for that. He has, together with his journalistic luggage, a designer's eye for the requirements of cover photographs: graphic, poster-like images with a strong sense of place and ample room for a logo and cover lines. On the occasion when we've both had the time to edit his work together after a major shoot, the unanimity of our selections has astonished me.

Stage's takes are complete journalistic entities—a beginning, a middle and an end—fully rounded out with choices of horizontals and verticals in nearly all situations. On his Southwest trip for *Travel & Leisure*, Stage was struck by the immensity and breadth of the country—the limitlessness of sky. Influenced by this spontaneous realization, many of Stage's images had a horizontal format, but, as usual, he didn't forgo the possibilities of the vertical format, not even in "Big Sky Country."

There are two basic schools of photography: "Window" and "Mirror." The "Window" school *reports*—it's the journalistic eyes and ears to all that is about us in the world. The "Mirror" school is, in effect, photographs *reflecting* the photographer's personality—inwardly directed pictures rather than outward looking.

John Lewis Stage is a window photographer. He feels photography should be proprietary. He eschews the "This picture and no other" attitude. His marked lack of ego probably comes from never submitting an image he doesn't want published.

John Lewis Stage

John Lewis Stage was born in Warwick, in Orange County, New York. He now lives about two miles from Warwick in a Kodachrome yellow house on a sloping meadow. His family has lived in and around the area since the 1700s. On his father's side there were mostly lawyers, and on his mother's side, mostly farmers. He finds his present location very convenient; it is about an hour-and-a-half ride away from New York. He takes his exposed Kodachrome to a drugstore in Warwick and gets the slides back in two days or so, and then he edits them at home.

He brings a sense of middle American values to his work, a certain visual and intellectual honesty and directness that, when mixed with experience and sophistication, produces images aesthetically satisfying and inescapably right. He considers himself primarily a journalist and is most pleased when someone says of his photographs, "Gee, you really caught it." He wants the reader to be enchanted with the subject rather than with the photograph itself.

I don't think there's any one particular way to get a story. At least not for me. Basically, I take all the knowledge I've acquired before a shoot, including information about the audience of the magazine that I'm shooting for, and I put all of this into my personal memory bank, my subconscious. Then when I'm on location, some of this preknowledge jibes with the actual place, and I begin to work on a more instinctive level.

Experience has made a lot of difference. I've learned over a period of time to develop certain instincts about who I need to contact to find out what I want to know. I always return to my mental picture of the situation, which guides my decision as to the people I should speak with. I consult all kinds of sources before I leave home; I've got *National Geographics* that go back over the last 20 years. I recognize that they're old, but they still give me a feeling about places.

Before I do anything, I try to put down my impressions, little key words about what I think might be unusual, indicative, or symbolic of a particular area because I'm always looking for the spirit of the place. That's the thing I really want to get. That's what I'm there for.

Everyone has a personal, preconceived concept of a place. Many of these ideas are fairly vivid. People who have spent a lifetime traveling around, reading books and magazines, and watching television digest all this information in a personal way. This unique viewpoint is what every photographer ultimately offers a client. Whatever an assignment may be, the approach a photographer brings to it is individually creative.

I try to get in touch with my own preconceptions. For instance, on a Louisiana assignment that I did for *Town & Country*, I have a bunch of notes, scribbles, and other symbolic data that I looked through in connection with my own thoughts about Cajun country. I went to the library and discovered there wasn't much coverage of Cajun country, but I found an art book that stimulated my thinking about the kind of people and ideas I wanted to photograph.

I think every photographer has a

certain repertoire of styles that may vary to some degree. When I look at an assignment, I think about the character of the place. I always use people, locations, lighting, and anything else I need to get through to the essence of a place, to get across that ultimate mood that captures what a place is, even if my technique has to change with the assignment. If I'm shooting for *Town & Country*, I might photograph one way but if I'm shooting for Mutual of Omaha, I would probably work another way. In photographing a trip through Spain, for example, I'd strive for a very

casual, sort of impressionistic and spontaneous style. That would be an entirely different approach, photographically, than if I were trying to do the great character faces of the various regions of Spain, which I might want to do in a more formalized style. I'd probably do New England in a different style from the Southwest. My approach also changes with the magazine or client I am working for and also with the type of writer that may be assigned to a specific project. In working closely with a writer to create a portfolio to go with a certain kind of story, I might

John Lewis Stage photographed the "High Desert" in Arizona for Travel & Leisure *in 1973. In 1982, he returned to the area to shoot an issue on the Southwest, covering the artists, craftspeople, movers and shakers, hotels and major tourist attractions.*

His style of photographing people for the 1982 shoot was consistent with his approach to portraits elsewhere. His subjects grow out of (or into) their environments, so a strong sense of the place is conveyed by his portraits, which are probing, lucid character studies in which the setting and the people become visually interdependent.

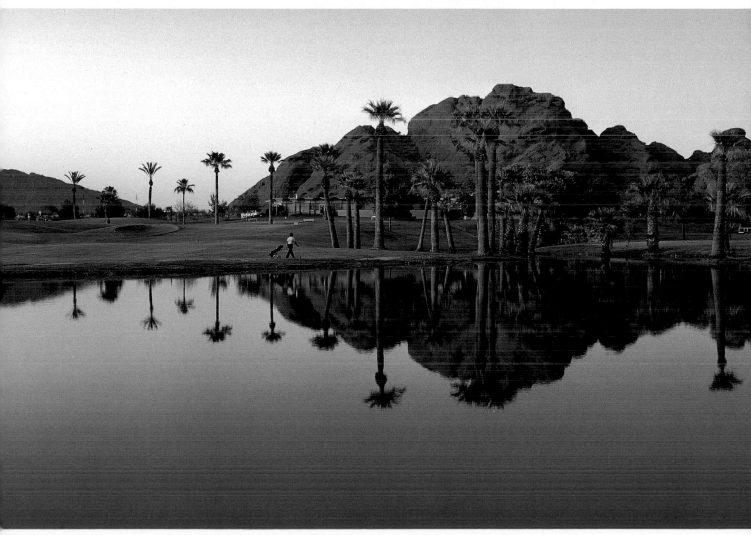

photograph differently, say, for James Michener than for Katherine Anne Porter or Jan Morris.

A photographer who doesn't know an area at all might want to spend a couple of days zooming around beforehand, scouting and soaking it up, and then determine the best approach to the assignment. I find myself doing that a lot. As a photographer, I'm in the position of knowing after I've finished a project what I should have known before I started it. But if I can determine at the outset what I will know after the assignment is over, I can usually improve my work a great deal.

Of course, some photographers shoot everything in their own style, come what may, and they apply their style to every situation. That is not my perception of the role of a photographer. Knowing that I'm a commercial photographer, I still take a certain pride in my journalistic role. I want to bring to each assignment my own offering (even if I'm not always sure what that is), and it has to be something I truly believe.

So I try to do some homework before I shoot. And that homework also includes making numerous contacts. First, there are basic sources—talking to people, journalists, and other photographers who've been there. And then there is doing the regular library research. After this preliminary work has been done, I go to the professionals—the Chamber of Commerce, the Visitors' Bureau, and similar places—to gather further information. I start to narrow my search down to the people who might lead me to interesting contacts, to other people who would have a lot of valuable experience and insights to offer. Many times these final contacts are artists, writers, or newspaper people who might have individual or compatible sorts of messages for me to pick up. I leave myself open for these kinds of instinctive messages and concentrate on them when I find them.

I can usually tell in one inexpensive phone call whether someone can offer me anything useful. And if so, that person need not

understand anything about photography or my particular goals. If I sit down with the right kind of person for just half an hour, I know there are going to be a few sparks— ideas will snap, and I'll think, "That's a photograph, yes, that's a shot." These leads can open up my awareness of a place and help focus my understanding of it.

I had been to the American Southwest before I did the November 1982 special issue on the area for *Travel & Leisure*. It was a multi-place assignment covering Phoenix and Scottsdale, Tucson, Indians, Santa Fe, and Taos. I'd made contact with the Chamber of Commerce people whose job it is to promote tourism in each of these areas. Although some writers wouldn't dream of talking to the tourist people, they do offer certain ways of getting things done and I think they're a good starting point. Over the years I've learned to accept available sources of information; it's simple courtesy to contact them.

I had a couple of contacts on the Southwest, people I knew from years

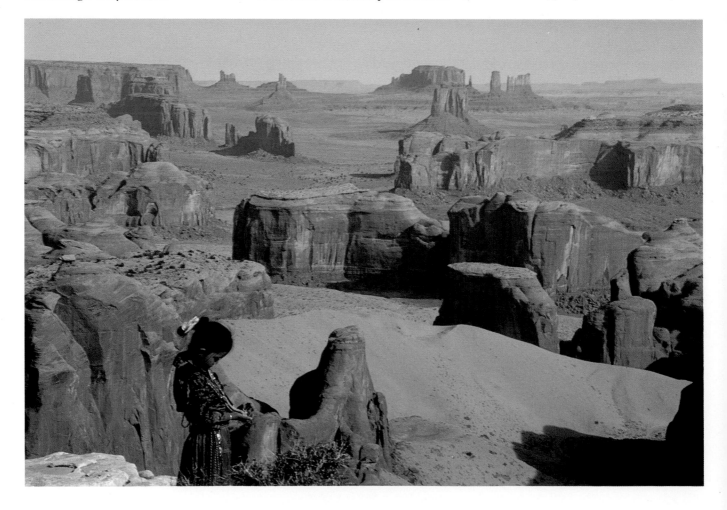

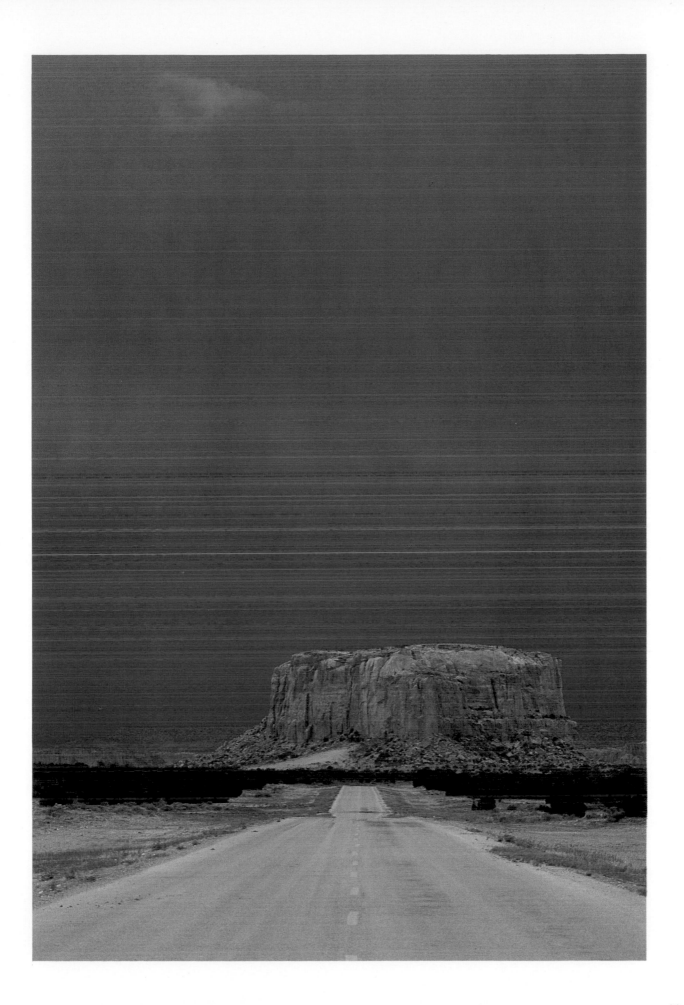

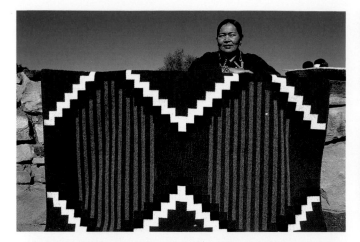
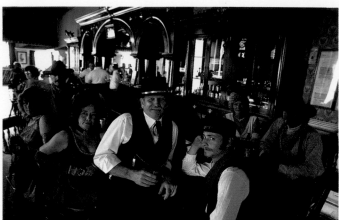

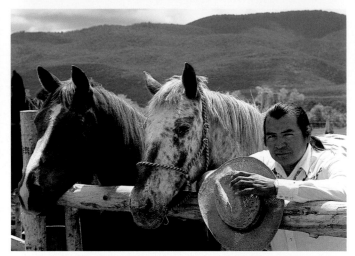

past. I called Neil Morgan and Jack Schafer, writers I'd known, to orient myself on the Indian cultures that are all over that area. I started with the Heard Museum in Phoenix, which is supposed to be the top museum in Indian crafts, artifacts, and culture. There I talked with the public relations person and the director. I always tell such people right up front who I am, what I'm doing, and what the purpose of my trip is. It's surprising how often their interests coincide with mine. And they're very willing to help. Sometimes I set up a meeting for half an hour or three-quarters of an hour and things grow out of that—such as contacts, books I should read, people I should talk to. So before I actually start shooting there may be six or seven people for me to call.

When I'm on location I use the phone an awful lot. I get referred, passed on from one person to the next, and the next, and the next. It's very important to be able to explain succinctly, quickly, and dramatically, what I'm doing and what I'm trying to find out, as well as to leave people an opportunity to help me. In other words, when I ask for help, people really do tend to respond. I have to be careful not to give the impression that I already know the place (even if I do). I've seen instances where the journalist *tells* people what is there instead of *asking* them. That kind of attitude closes doors very quickly. The trick is to really *ask* for help, enthusiastically. I've got to keep my ears open and be willing to listen and look at a lot of things in the hope that something is going to strike the right chord. Then I can say, "Ah, that will epitomize the original impression that I wrote down before I left home."

The first few days when I'm wandering around, I make notes of my impressions in the car or back at the hotel. I keep constant notes—about the time of day, the light, about vantage points. If all that information feeds into my brain, it hopefully all comes out again when I use my camera.

A lot of my work depends on instinct, a lot on experience, and a lot on how interested I am in whatever I'm doing. We all have some things we're more interested in than others. If I find that I'm not really getting jazzed up, my professionalism has got

to compensate. Or I've got to find another way to set the assignment up. And I must be truthful about whether it's working or not. I can't just *hope* that it's working out okay, and if I find myself doing this, it's probably not working out as well as it should.

Human beings are interested in other human beings perhaps more than in anything else. People in their own environments can tell as much about the environments as about the people. That's as true in the American Southwest as in South Africa. All over the world, people portray the visual alphabet.

I have no predetermined portrait "arrangement" or fixed style. The force of my subject's personality, the place and its scale, whether or not the land dominates the personality or vice-versa, all of these factors combine with my own personal reactions to the subject to determine the portrait.

Most people who become picture subjects really do enjoy being photographed. They're sort of honored. Everyone likes to think he or she is unique. If I also feel the person I'm photographing is unique, that comes through and the subject is going to like that. Then if I ask them to do something a bit extreme, if it's appropriate, they will usually agree. It's playing to their vanity, but I don't hesitate to ask for that kind of cooperation. Of course, I want them to enjoy the shoot. Location photography is all show business, really, except when I'm working with a professional hotelier or restaurateur who's going to get something out of it directly. But if I'm working with people whose only benefit is personal satisfaction or fun, then I have to make sure that it is fun. It's important to go along with them too, as to what their ideas are or their perceptions of themselves. Location photography is really a lot like cooking, a lot of mixing things up, and following my instincts as I go along.

I make lists of all the definite pictures I want to make, and I list the kinds of options I would like to take, such as it would be nice *if* . . . I can do this *if* . . . here might be a way to get something across. I find I previsualize pictures on layouts for certain art directors, such as Adrian Taylor and Melissa Tardiff, who is the art director at *Town & Country*. I

41

never do it with *Gourmet* or some of the Time-Life books because I don't know how their designers are going to approach the work.

I save everything: notes on places, impressions of people, the angle of the sun at specific times of day, architecture and interiors, whatever will help later on. Sometimes that may mean years later on another assignment. I also carefully and fully caption all my takes. This is not a universal attribute among photographers, but a welcome one to an art director or editor.

When I see what looks like a double-page mood picture, I tend to move into that format and really milk that setup for everything I possibly can. Sometimes when I get back, I discover another picture that I wish I'd worked on more, I'll see that there was something better down the line, the next day or the one after that. If only I'd known, I could have milked the second pictures instead. So some guesswork is involved in what I do.

I always know that I'll need closeups, scenics, variety, and different kinds of people for an assignment. If the story or the area feels youthful for instance, I'll concentrate on youthful people. If it's one of pure visual delight, such as the Southwest assignment, then its the landscape and its color, the earth tones and the big space that I really want to show. For example, the still-raw quality of Phoenix is somewhat glittery. Tucson is more Mexican, more cowboyish, certainly not like Phoenix in that respect, but more raunchy and down-to-earth. Taos and Santa Fe are more arty and more wild, making shots of them more predetermined.

The Southwestern Indians live within their own physical and cultural parameters. For instance, the Pueblos live in a certain way and the Navajos in another way. That's some indication of how to go about photographing them. The Indian women are important and, in terms of the arts, are coming on stronger and stronger.

Then there's the land of standing rocks, an unbelievable geological Americana that you won't find anywhere else in the world. And the scale—try to get that huge scale! I kept asking myself, "Am I *really getting* this huge expanse?" After a photographer has been on location

for two weeks, it's easy to lose those first impressions. Unless I recorded some of the land's more obvious features right away it would have been easy for me to overlook them.

The reason American photographers are sent to Europe and European photographers are sent here is because we've found out it's important to get fresh looks at things. I have to do that for myself. When I went to the Southwest I kept repeating to myself, "Okay John, be open, be open to new things, keep yourself wide open." Of course, this depends on whom I'm working for. Some clients are more receptive to my being open than others.

Traveling with a writer is hard for me and is hard for most photographers, I think, because writers do not seem to need visual truth. They experience life intellectually and can miss the essence of a place that photographs can capture. I really have to be true to myself and my own instincts, in order to bring out my sense of this essence in my photographs.

I know when I'm shooting a "cheap shot." And I know viscerally and visually when I'm shooting the real thing, the picture that means something to me. Every day I shoot, I evaluate my take to determine what I've missed, what doesn't measure up. It's a very personal thing, and it defines my own sense of visual truth.

COVERING A COUNTRY

Its not hard to be intimidated by Burt Glinn's photographs of Japan. After building friendships and contacts for 20 years, he knows exactly which buttons to push to get to the places he needs to shoot and the people he needs to see. And he's a superb photographer. But he was not always on such intimate terms with Japan.

Let's jump backward in time, nearly 25 years, to a younger Glinn and an older Japan. Before he went to Japan for the first time on assignment for *Holiday*, he read everything he could on the country. On arrival, he contacted Ray Steinberg of *Newsweek* and the tourist agency, and he spoke to newspaper people and other photographers. His first visit to the Island Empire began professional and personal relationships that have grown richer throughout the years.

Glinn advises: "Get the best guidebook of the country and call the author. If I were going to Chicago tomorrow, I'd think nothing of calling Studs Terkel today." He cautions, however, against going to the bureaus of other publications. "You might really wind up with *their* point of view and not the point of view of the magazine you're shooting for, or even your own."

Setting up the *Travel & Leisure* piece, Glinn and I had several one-on-one conversations about the parameters of the assignment. On other occasions editors were at the meetings, including one who had lived in Japan for a couple of years, Malachy Duffy. At these meetings, the parameters were defined geographically: Tokyo, Kyoto, Kamakura, and Nikko, for instance, were delineated according to which restaurants and hotels would appear in the articles. Furthermore, the nature of the magazine dictated that no poverty and no politics be shown. Glinn thus amplified his coverage within the context of his knowledge of the material needed and the limits of the story.

The contrasts he found (gangs on the street, and Kabuki in the theaters) became obvious after he shot some of the pictures, and ideas suggested themselves as he went along. For instance, the Hollyhock Festival was going on while he was there. To have ignored it would be like ignoring Mardi Gras in New Orleans. Glinn felt that once he had the outlines of the assignment and had covered the mandatories (hotels, restaurants), he could use his priceless contacts to meet designers and actors, and to scout some of the more unusual districts of Kyoto and Tokyo. He wanted to really get beneath the surface, and he did.

When he returned with (as I recall) seven or eight trays of transparencies, Glinn, picture editor Bill Black, and I ran through the trays, making a mental edit of the photographs. First selects were later pulled, and then a final edit was made for layout. Editorial staff members joined in our efforts to assure that the pictures tracked with the stories.

In Glinn's earlier *Holiday* story, he'd done his own photographic piece, and Laurens van der Post wrote another. This duality of coverage made a rich mix of material, but it didn't provide the useful service information that travel magazines today include as their stock in trade. The *Holiday* piece was another kind of journalism. The *Travel & Leisure* issue was a much more conjoined effort; the photographs, where necessary, substantially reflected the text.

Burt Glinn

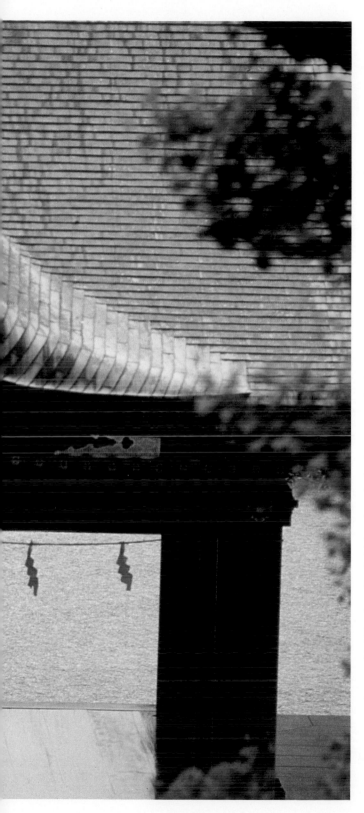

Burt Glinn, sartorially splendid, urbane, and elegant of manner, is known affectionately among his peers as "Chairman of the Board." Glinn first became known for his spectacular color coverages of the South Seas, Japan, Russia, Mexico and California, each of which was published as a complete issue of *Holiday* magazine. Collaborating with author Laurens van der Post, he has produced two books: *A Portrait of All the Russias* and *A Portrait of Japan*. Recent editorial stories have included "Los Angeles" for *Esquire* magazine, "The Metropolitan Opera" and a cover essay on "The American Harvest" for *Fortune*, "Haiti" and "Great Cats of Kenya" for *Travel and Leisure*. Reportages in magazines such as *Life* and *Paris Match* included the Sinai War, the U.S. Marine invasion of Lebanon, Castro's takeover in Cuba, and personality profiles on Sammy Davis, Jr. and the late Senator Robert Kennedy, among others. He photographed both political conventions in 1976 for *Newsweek* magazine and his essays on "Windows on the World Restaurant" and "Op Sail '76" are still in print.

As an undergraduate he won the Dana Reed Award from Harvard University. Subsequently, he received the Matthew Brady Award as the Magazine Photographer of the Year from the University of Missouri and the Encyclopedia Britannica, the Award for the Best Book of Photographic Reporting from Abroad from the Overseas Press Club, and the Gold Medal for the Best Print Ad of the Year from the Art Directors' Club of New York for his Foster Grant Sunglasses ads.

During the last few years he has photographed for the annual reports of Pepsico, Olin, Pfizer, General Motors, Inland Steel, IMC, Richardson-Merrell, Damon, Xerox, AMF, Revlon, Bristol-Myers, Northeast Utilities, CONDEC, Consolidated Can, Alcoa, Goldman Sachs, among others.

His advertising clients include IBM, TWA, Seagrams Whiskey, BOAC, Chase Manhattan Bank, the Government of Puerto Rico, Sabena, Geigy Chemical, ITT, ESSO, Sea & Ski, Dry Dock Savings Bank and Gulf & Western.

Glinn was one of the original contributing editors to *New York* magazine and continued in that capacity until early 1977. He was president of the American Society of Magazine Photographers and has been a member of Magnum since the beginning of his career, serving three terms as its president and once as chairman of the board. He is based in New York.

I have been taking pictures professionally for 37 years, which means I'm no longer qualified to be considered the Bright Young Photographer. I got into photography because I was always interested in journalism. My first and only staff position was the nine months served as an assistant to the photographers at *Life* magazine during its heyday. I learned a lot from this post by working with all the photographers and getting to know each of them individually, including Eisenstat, Cornell Capa, Nina Leen, Margaret Bourke-White, and some photographers you don't even hear about anymore. It was a very pleasant life and I learned everything I could.

By the time I'd been there for a month, I knew a lot about strobe lighting. In those days you could always tell an assistant from his burned hands—screwing in flashbulbs was dangerous because they often went off in your hands. When the great war photographer Bob Capa came back from Europe, the editors had me sit down with him to explain how to balance flash lighting with daylight because he'd been given an assignment in the French Alps. Afterwards, whenever we met he'd say, "Oh, you're the one who knows how to use flashbulbs. You ought to join Magnum." (He said that to everybody. I have shown up in Afghanistan as a photographer for Magnum, and the guy taking tourist portraits with wet plates in the main square has said, "I'm with Magnum! Capa was here!")

There wasn't much future in being an assistant, so one day I quit. I had been thinking about going to law school, but I really didn't know what I was going to do. I went home and the next day *Life* called and gave me a photography assignment. I started working for them regularly, and within a month I'd had my first *Life* cover. I've been working freelance ever since.

I stayed around New York doing the things you do as a young photographer. *Life* was my big client. Photography was a much more intimate profession then. There weren't thousands of photographers, there were barely hundreds of us around New York. Everybody knew who you were in the business, even if you had just started.

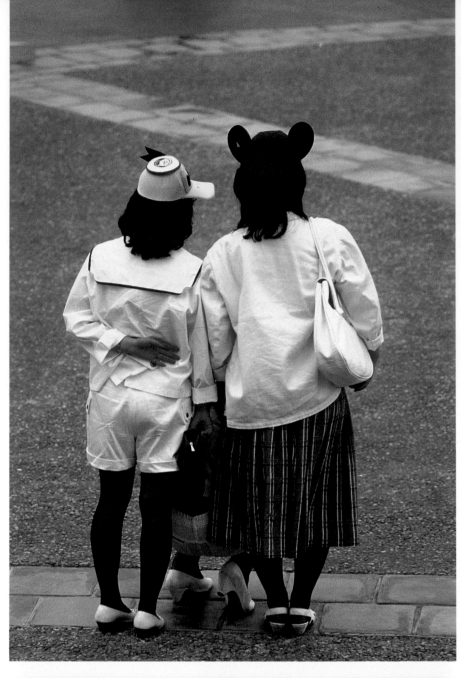

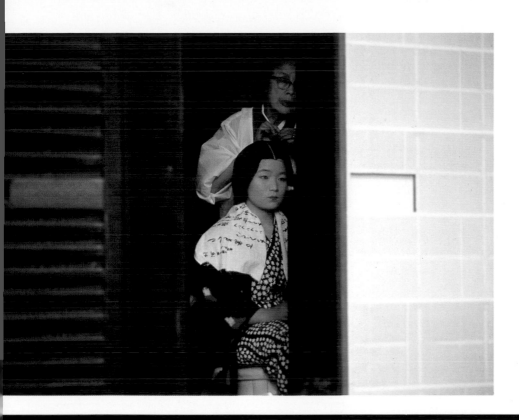

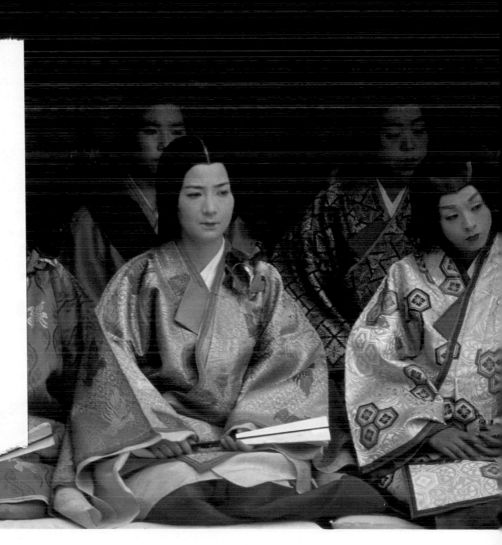

It was very informal in those days. In 1952, when I decided to move my base to Seattle, I figured I ought to have an agent. I had met a woman named Inge Bondi who worked in the Magnum office, and we made an informal agreement. I kept my *Life* magazine income for myself, and Magnum kept a percentage of everything else. That could never happen today. Magnum sent me on tour with the Queen of England to Bermuda and a couple of other places in the Caribbean, and I discovered that it wasn't just the photography I enjoyed—the whole ambience was very interesting.

I had been with Magnum in one way or another for two years when, in 1954, there was that terrible week that both of Magnum's top photographers, Werner Bischof and Bob Capa, were killed. I flew back to New York and discovered that everybody thought Magnum would collapse. At that time I was doing a lot of work for *Life*. I shot forty or fifty pages a year out of Seattle, and I was quite successful—

all that money was coming directly to me. So I offered a percentage of everything I made to Magnum because it was in such a crisis. That's what cemented my relationship with Magnum—I was part of it from then on. It's a long time now, 32 years.

Every Sunday the main street in the Harajuku district of Tokyo is closed and young Japanese emulate Western rock and punk bands and styles in the street.

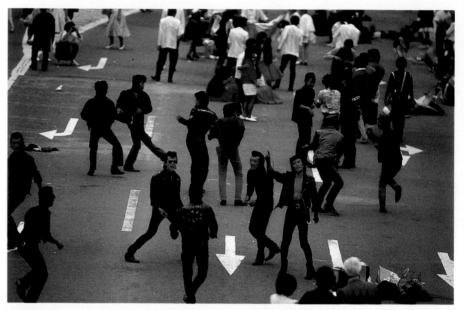

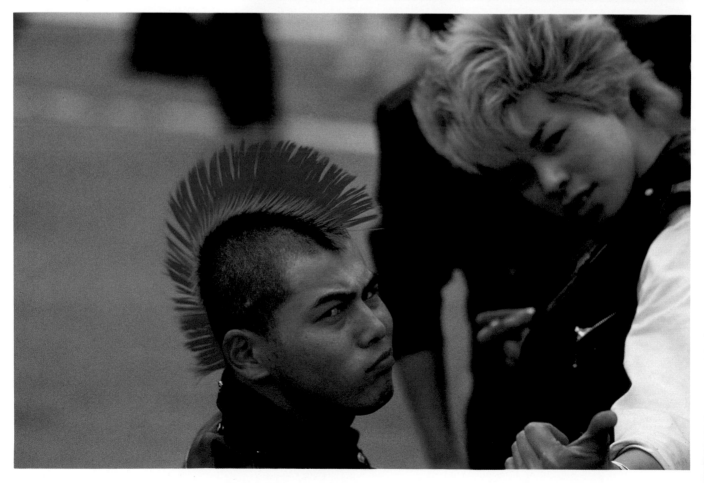

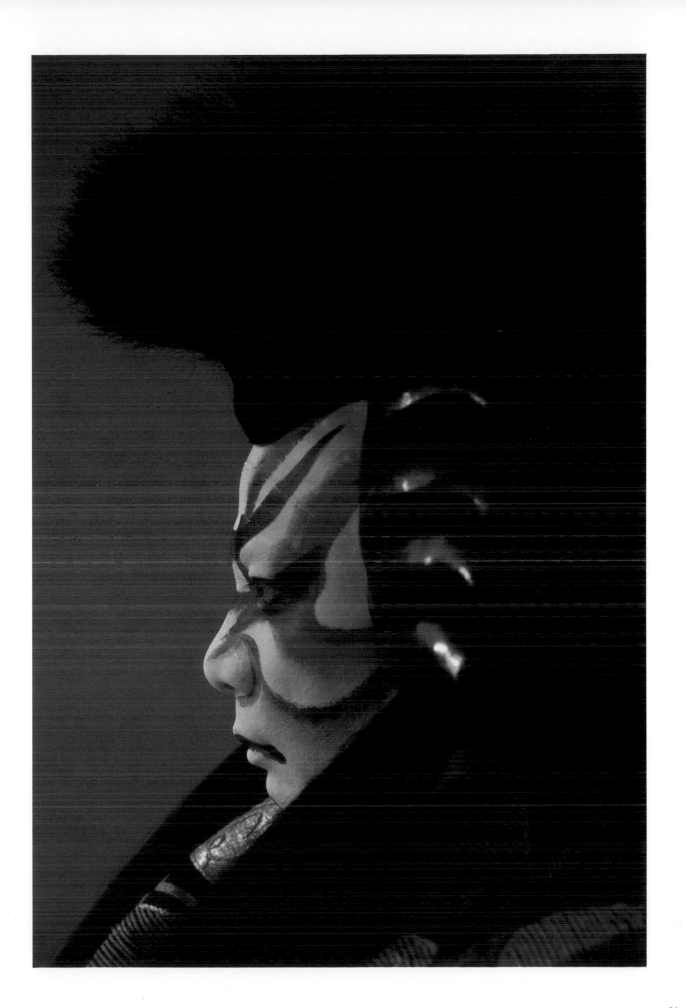

After the memorial services for Capa and Bischof, which were wrenching experiences, my friend "Chim," David Seymour, who had become Magnum's president, and I stayed around New York and spent some time together. We had a lot of talks, and finally he said, "Well, when are you going to move?"

I replied, "Gee, Chim, I have the whole Northwest out there in Seattle. I have *Life* magazine there, my friend is the bureau chief. I live very well, and it isn't expensive. And I'm kind of a celebrity in town—even though I'm not the *Life* staff photographer, everyone considers me the *Life* photographer. Anybody who has anything to be done in the Northwest usually comes to me unless it's really big."

Chim looked at me and said, "Well, you've got to make up your mind about the kind of photographer you want to be. Either you're going to be the kind of photographer you are now, where somebody says, 'We have a job to do in Washington State. Who's out there? Oh, Glinn is out there. We'll use him.' Or you're going to be the kind of photographer where somebody says, 'We've got a job in Timbuktu, and I want you to get Burt Glinn to do it no matter where he is.' "

It was Chim's idea that I should move to Paris and work in Africa, that kind of assignment. Chim was used to getting Henri Cartier-Bresson to do a story in China or Werner Bischof to do Japan. It was a good idea. From 1954 on, I spent less time in Seattle and more time traveling, and I began to get some good assignments from *Holiday* magazine. *Holiday* was as instrumental in getting me around the world as *Life* was. In 1959, *Holiday* was doing an issue on the islands of the Pacific, and they asked John Lewis Stage to do half of it—New Zealand and Tonga—and me to do Tahiti, the Micronesian Islands, and New Guinea. It was really a marvelous time because the Pacific still hadn't been touched. You couldn't fly directly to Tahiti. Even Marlon Brando hadn't been there yet.

When John and I returned, we had so much material between us that *Holiday* made it a double issue, October and November. Each of us had the equivalent of an entire issue split between the two. This planted the idea of *one* photographer doing a whole issue alone. I kept saying that I would like to do a whole issue, so they came up with the idea of my doing the October issue, and I did it for four years running, every October. I shot Japan, Russia, Mexico, and California.

It was wonderful working with *Holiday* on anything in those days. The world was less expensive, and we had time to do things, even without taking free air fares or free hotel rooms. We didn't spend time like the *National Geographic* did. I remember coming to Singapore to do a story for *Holiday* and running into the *National Geographic* photographer and I said to him, "Listen, do you think I can shoot Singapore in two weeks?" And he said, "I don't know. I've been here three months." I could never do that because I like intense work and then moving on.

I was very eager to shoot Japan because of its past connections with Magnum. Japan had been a big turning point for Werner Bischof, whom I had met only three or four times. Bischof was a Swiss photographer, and before he went to Japan he had done very precise, wonderful still lifes, very cool. Somehow he went to the Orient and it turned him around. He did one of the first of the great photographic books. It's a classic marvelous book called *Japan by Werner Bischof*. By that time I was very friendly with Marc Riboud, and since Japan had had a very big influence on him as well, I too was eager to go to Japan. The Magnum people all said they'd give me letters of introduction.

I went to Japan not knowing anybody, but through a Mr. Okomoto I met Hiroshi Hamaya, whom Cartier-Bresson called the greatest photographer in the world, not just in Japan. Japan Airlines and the Japan Tourist Bureau were both very helpful because it was important to them that Japan was being featured in an issue of *Holiday* magazine. But my biggest break was meeting Hiroshi Hamaya and, through him, other Japanese photographers. They were all just terrific.

The important story from that particular *Holiday* issue was that Hamaya took me to meet an old Japanese photographer who did nothing but take pictures of Mt. Fuji. He had spent 50 years photographing the mountain, and although they weren't the greatest pictures of Mt. Fuji, he seemed to know everything about it. He was generous with this knowledge and it was a great help to me. We were lucky because we did pictures of Mt. Fuji that are still being used today, still being printed, and people are still buying the prints.

If you're a photographer, what is most important is what you bring to a story. For shooting, it's the quality of the information you get. You've got to *know*. Cartier-Bresson once said, "It's terrific to photograph Pamplona, but it's better when the bulls are running." There's nothing more aggravating than being in a place, looking for certain kinds of things, and then waking up the next morning and seeing a picture of just what you were looking for two cities away, something that you didn't know about beforehand.

Hamaya and Asa, his elegant wife, took me to Hamaya's hometown of Nigata where we photographed the rice planting. Every time there was a problem, I asked Hamaya about it. I not only got a solution, I got *the* solution. What I mean is that I didn't ask him what kind of film to use, for instance, but I did ask him where to find a certain kind of feeling in Japan. For Hamaya and Asa were the epitome of real, genuine elegance. They were unusual people, both very international and very traditional-minded at the same time.

Hamaya was building his great house at Oiso and was living in straitened circumstances. You wouldn't have known it just at that moment, but he was really a very wealthy photographer. He used to call their home the "Radical University at Oiso" because they were not of the establishment, although they were accepted by it. When they finished their house, it was built without a single nail in it, and all by Japanese craftsmen. The darkroom was black slate and had its own garden. It is an incredible place. Hamaya doesn't speak English and I don't speak Japanese but we worked without interpreters and somehow made ourselves known to each other.

One of the interesting things about working for *Holiday* was that you didn't have to read a piece to do the pictures because they really didn't want the pictures to illustrate the piece. They let the photographer do one piece, and the writer do another,

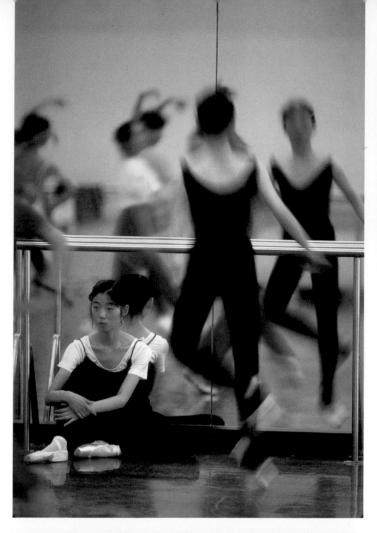

*The Matsuyama Ballet Company
practices in Tokyo, in sharp contrast
to these sumo wrestlers going
through morning practice at
Dewanoumi Beya Sumo stable.*

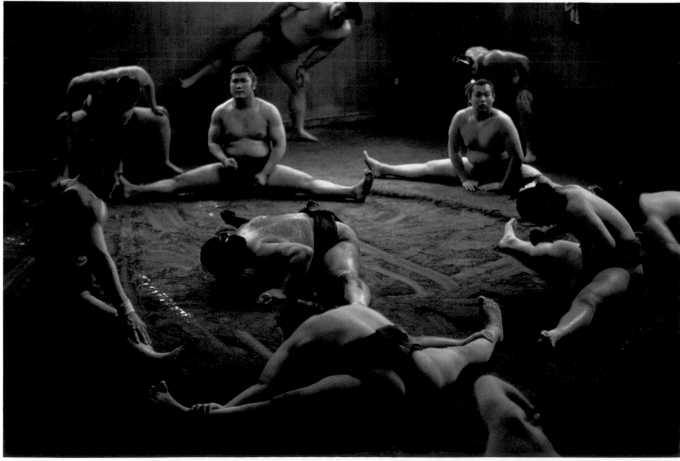

separately. I think it's the best way because if you start illustrating other people's ideas you tend to get stilted pictures, and not real pictures. You have to lead with your own instincts. Writers tend to tell the truth in their own peculiar ways. I'd never met Laurens van der Post, the writer assigned to the Japan issue, until it was published. He had not written the piece when I went to photograph it.

And in those days you could do things that are very different from what you can do now. If you read that issue of *Holiday*, you will find that they were telling you about wonderful bargains, about staying in a double room at the Imperial Hotel for $14, and having steak dinners for $4 or $5. Japan was inexpensive in those days.

Holiday let me go to Japan twice. The first time was in the fall. They seemed annoyed then that I spent the first month on this big project gathering information and not taking a lot of pictures. But as usual, I needed to know where I was going, how I was going, and where things were. Today it doesn't take me long to

gather information because I have all my sources, people that I have known for a long time, and it's easier.

I came back from the fall trip with some good pictures, but not a lot. I could see that Frank Zachary, the editor at *Holiday*, was beginning to sweat bullets, so I said, "Don't worry. It'll be fine." Then Frank came up with the issue's big idea. We had one terrific picture that I had taken of Mt. Fuji. The day I shot that picture, I hadn't been heading for the site where I made the shot. Arnold Erhlich from *Holiday* had just arrived in Japan. He turned out to be my good-luck charm that day. He said, "I'm going to Hakone, come with me." And then there it was, Mt. Fuji on a clear day, very unusual, and these ladies in conical hats were chopping rice in front of it. When Frank saw that picture, he said, "Why don't you depict Mt. Fuji just as the artist Hokusai did? Why don't you take 100 views of Mt. Fuji, just as Hokusai etched Mt. Fuji in woodcuts?"

It was a terrific idea. The great thing about Frank is that he never told people what to do. He had ideas. Frank would always have a good

Eiko Ishioka is a famous Japanese graphic designer, shown here on the set she designed for the Golden Pavilion sequence in the movie Mishima.

germinal idea. He'd say, "Read this writer" or "Look at this painter." But he never *told* you. He never had this long list of silly pictures. You had to *find* the pictures yourself. What drove me crazy about the old *Geographic*, was that people who worked there used to get a list of 100 pictures they had to take, and then these pictures became "assignments." Having a list was something I had grown away from while at *Life*, which made *Holiday* perfect for me to work for. *Holiday* didn't give you preconceived notions to illustrate. You *went* and you *found*. That's the essence of journalism and good photography, to go where your information, your nose, and your instinct lead you without being told for instance, "Be sure to get a picture of the baseball factory where they're sewing up horsehides."

That first trip to Japan was a great opening for me. When I did the trip for *Travel & Leisure* in 1983, I had already been to Japan about 20 times and Hamaya had become a really close friend. I'd also met Bob Kirschenbaum, who became Magnum's agent in Japan. But don't think that developing a good network means that if you meet somebody, you strike up a friendship only because they're useful to you. That kind of opportunism contaminates the relationship and it contaminates any real exchange of thoughts and ideas. If Hamaya couldn't tell me anything about Japan, he would still be a great friend. If Kirschenbaum couldn't do anything for me or sell a picture, he would still be a friend. The trusting nature of a real friendship makes the information exchanged yield depth and substance. Friends don't tell you trivial things.

When I did the *Travel & Leisure* piece, it was about the third time I'd been in Japan in eighteen months, and each time I had been there, by some strange coincidence, Elliot Erwitt and Ernst Haas were there at the same time. We had some incredible nights in Tokyo, none of which led to any specific pictures but instead opened up our thinking. We were with Hamaya and he led us into these little places that we'd never have seen under any other circumstances. We saw Japan in a different light than we would have seen it in if the Tourist Bureau had guided us around.

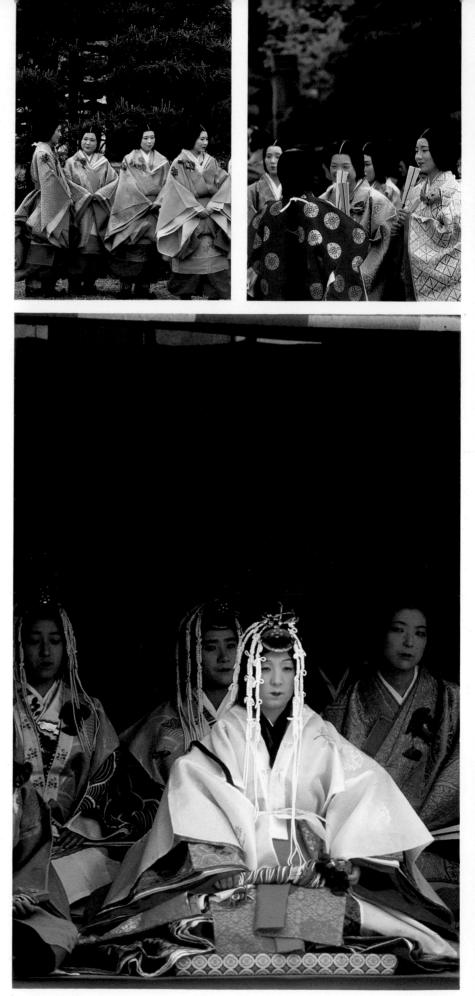

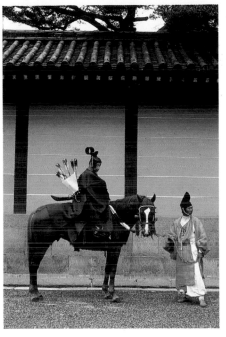

During the Hollyhock Festival in Kyoto, hundreds of people dress in ancient traditional costumes. They gather at the Imperial Palace grounds in Kyoto, form a procession through the streets of the city, and go through a religious ceremony at Shimogama Shrine that recreates the court ceremonies of ancient Imperial Kyoto.

Going out with Kirschenbaum, Haas, Hamaya, and some others was really the key to my continued involvement while shooting in Japan. We met all kinds of people, none of whom were on the tourist beat or the journalist beat. That's how you get to do exciting and original photography. You'll never find this kind of itinerary drawn up by somebody in New York. I have a great time whenever I go to Japan, and it really is due to the people I met on that very first trip. The quality of the people you meet, not just as professionals but as friends, helps a lot.

All these thoughts came to me while I was sitting in my hotel room in Tokyo on assignment for the *Travel & Leisure* piece. My hotel room cost somebody $180 a day, and I was worried about spending a further $100 to get a decent dinner in Tokyo. Then I opened the old *Holiday* issue, which was at that time 25-years-old, and I read about the places I had covered 25 years before, comparing them to the places I would cover now. I thought, "God, no wonder we have problems now; nobody will subsidize you to take two or three trips to Japan because no one can afford it." For the *Holiday* issue, I was in Japan three months. In order to shoot for three months in Japan today, you'd have to have a foundation grant.

I spent 17 days on the *Travel & Leisure* piece. It might have been 40 days except for the nature of the people who were helping me. They were just terrific. But in 17 days I didn't get a lot of sleep, or a lot of rest, and I wasn't able to relax much because I felt under pressure to fulfill all the assignment's requirements in a reasonable amount of time. To do that I had to stay in a hotel where I had good facilities.

I covered Kyoto for *Travel & Leisure* in two days, which is almost unheard of, but I knew where to go and what to do. It was the Hollyhock Festival that I wanted to photograph. I almost didn't get in because you're supposed to have all kinds of accreditation that I didn't have. But I did get in, and shot the magazine cover and a couple of important spreads. I noticed that other photographers weren't shooting the festival; perhaps they were looking for other things.

I wouldn't say that 17 days shooting in a country like Japan is ideal. But there were certain requirements that I had to meet because *Travel & Leisure*, being *Travel & Leisure*, needed some hotels and restaurants that I wouldn't normally do.

I believe that a good strategy for a great future in photography is to establish yourself first, do things to make money, and after that you can pursue your own assignments. When

you're shooting for yourself, you don't feel hampered by obligations to your clients.

Or you can go, like some photographers do, and live off the country and take marvelous pictures, better pictures. It's unfortunate that so many interesting ideas come in hotel rooms. The last place a photographer should be is in a hotel room—no one can take pictures there.

The other thing that helps a lot is

not to think in stereotypes and to try to avoid people who do, people who have been somewhere once or haven't been there at all, and who tell you what to photograph. One of the great traps for some photographers, is that *they begin to take pictures of other people's pictures.* The ideas that everybody already has about a subject come from having seen them before. Editors who haven't been to Japan or who have been there perhaps once on a quick four-day trip are shown the usual things and their ideas may come from seeing other photographs so that's why they'll want cryogenic, or quick-frozen, images.

I know there are a lot of photographers who thrive on doing the same story over and over again. If they're great photographers they won't do the same *image* over and over again, so that's okay. But I like to hit a story, get out, and move on to the next challenge. I think photographers should rely on their own impressions about a place. They should use information, but if possible, they shouldn't go to an assignment with a long list of imperatives. Another recommendation for photographers is not to look at old magazines beforehand (see John Lewis Stage, page 36, to the contrary) because you can never take the same picture over again. Also, even if you decide not to reshoot a published image, it's still imbedded in your mind. You can't forget it. I would *read* about the place instead.

I met Laurens van der Post after I did the first Japan issue for *Holiday*. It just so happened that he and I had taken the same approach to this country. However, I've done *Holiday* stories where I photographed something entirely different from what the writer wrote. (I remember doing a story in the early '50s on Montmartre, which Joe Wechsberg wrote. Joe had written a piece saying, "Oh, Montmartre isn't like what it used to be." I was a very young photographer and I said, "Oh, Montmartre! Artists, windmills and everything.") It turned out that van der Post, who was kind of a mystical writer, wrote about Mt. Fuji in the moonlight, and I had shot this big double page picture of the moon rising over Mt. Fuji. He decided we

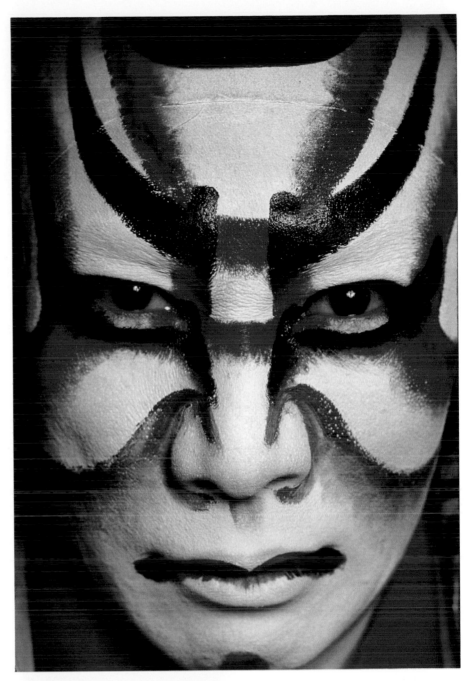

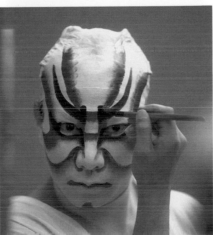

These pictures show master Kabuki actor Ebizo wearing makeup for a character called Kagekiyo, taken in a dressing room backstage at the Tokyo Kabuki Theater.

A rainy day at Shinseno Temple in Kyoto.

had something in common and we became friends soon after. We did the next big *Holiday* assignment too, which happened to be Russia.

We didn't go together though, and we didn't confer with each other either. We happened to be in Russia for two or three days simultaneously, at one point in my trip. We never discussed what he had written, but he did say, "Before you go, read Chekhov and Tolstoy." This was the best advice I could possibly have been given, because it sensitized me to Russian writers. They always write about the landscape and how the country *feels*. I was in my 30s when I went to Russia for the first time, and if you're an approaching-middle-age-American photographer without any experience of Russia, a white birch might be just another tree to you. But if you've read the Russian writers on white birches, then you become sensitized to them. You're not sensitized to them in a *visual* way so that you're mimicking somebody else's photographs. Instead, the feeling is in your head; that's the greatest way to work.

That's why I always liked working for *Travel & Leisure* or *Holiday* better than any other magazines. It was the Magnum photographers who left the deepest impressions on me—Haas, Cartier-Bresson, and Gjon Mili,

because he was tough on me. Frank Zachary was very important too, because when nobody else thought that much about me, he just let me do what I thought I should. He encouraged me without *telling* me. Maybe it was because the people at *Holiday* were too busy having a good time themselves and weren't going to go out and do a lot of dry research to tell photographers what to do. And maybe it was just that their instincts were right.

I do a lot of commercial photography now and a lot of annual reports. As I've grown older, I've become impossible in some ways because there are people who now pay me for three days what *Life* used to pay me for a whole year. I usually try to loosen up these clients so that they don't say, "Be sure to take a picture of our great Framus machine —we spent three million dollars on it." That is so *inhibiting*. I say to them, "If you want to tell me what to shoot, you should hire someone else who'll do exactly what you want for less pay. I can't work very well for you if I've got to shoot what you want me to shoot. Tell me what you want to *say*, and tell me what the subject matter is, and let me find the way to say it. Otherwise, if it doesn't work out, I'm going back to law school next year."

This is a traditional Japanese tea ceremony at the Urasenke School. The woman's name is Hisako Kusunoki.

A GEOGRAPHIC SAGA

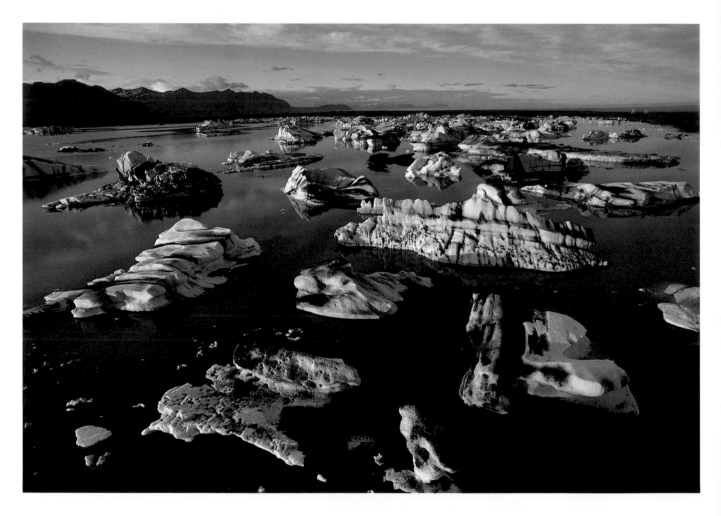

An assignment from *National Geographic* is a real plum for any travel photographer, and hard to get. Bob Krist is finishing his third assignment for the magazine, and while he admits the Washington, D.C.-based founding-father publication of the travel genre is a tough nut to crack, he thinks it's worth it. *National Geographic* has done everything and gone everywhere, at least once. Half the photography used is produced by staff/contract people and half by freelance photographers.

National Geographic coverage runs in roughly ten-year cycles. The way to get an assignment from them is to find a subject (place) that hasn't been covered for several years. (Do your homework and research.) Then you should write a one to three page story proposal and, along with a tray of about 80 slides (to show some general idea of your ability), try to make an appointment with the Director of Photography, Tom Kennedy. It would be prudent to write a letter first, suggesting a date for an appointment. Follow-up with a phone call, and expect some early disappointments. They are rather busy and everybody wants to shoot for them.

If your story proposal is interesting and can demonstrate to Tom Kennedy a certain minimum photographic proficiency, he might pass your proposal along to the Planning Council. The Planning Council (the very sound of it is daunting!) meets nine or ten times a year. Members specialize in certain areas (one or two for Europe, one for South America) and their word is usually final.

If the Council approves a story idea, it goes back to Kennedy for assignment. The *Geographic* is scrupulously honest about assigning a story to the photographer who proposed it (I-go-home-with-the-one-who-brung-me school of integrity). If Kennedy feels your idea is good (and the Planning Council approves it) but he feels your photography is wanting, you'll be paid for your idea. They will not say, for instance, "We like the idea but we can't use it right now. Sorry." And then you will see it in print a year later, shot by someone else.

National Geographic, by and large, isn't interested in self-assigned takes. But they might say, "Well, you've got a nice start on this one." Then if you get the assignment based partly on your self-assigned take, you can look forward to three or four weeks (or more) of shooting and research and more shooting to satisfy the magazine's broad, deep-coverage requirements.

All of Krist's assignments were suggested by him via story proposals *in writing*. And he's a very good writer as well as a superb photographer. Ideas are all-important, as the *Geographic*'s former Director of Photography Bob Gilka once said, "I'm up to my ears in talent but only ankle-deep in ideas."

Bob Krist

Bob Krist is an award-winning photographer whose work appears regularly in magazines like *National Geographic*, *Travel & Leisure*, *National Wildlife*, and *Islands*. During the course of his assignments, he has photographed the remote glaciers in Iceland's interior, secret voodoo ceremonies in the steaming jungles of Trinidad, and active volcanoes off the coast of North Africa. In addition to his magazine work, Bob photographs annual reports for many of the Fortune 500 companies.

Bob's original career plans did not include photography. Before graduating Springfield College with a degree in English Literature and Philosophy, he spent summers working as an apprentice actor in a regional theater company. He bought his first camera when, as a member of an experimental theater group, he spent a year touring Europe presenting the work of new American playwrights. Later, while studying in London and performing in several fringe theater productions, Bob worked as a grill chef and pub bartender to help make ends meet and support his newfound photography habit. He continued his photographic pursuits during subsequent acting stints at the American Conservatory Theater in San Francisco, and repertory companies in Berkeley, California and Philadelphia.

Bob's first professional photography experience came in 1976 when, during an unusually long period of being "between engagements," he applied for a position as a photographer on a small daily newspaper in northern New Jersey. To his surprise, he got the job, and spent the next three years learning the photojournalism ropes while covering the rough and tumble street life and politics of Jersey City, Hoboken, and the surrounding areas for *The Dispatch*.

In 1979, Bob left the paper to freelance and his first major assignment was to cover his home state of New Jersey for a story in *National Geographic* in 1980. He never went back to the stage, but as Bob Gilka, the former Director of Photography at the *Geographic* wryly observed, "Krist has been acting like a photographer since he left the theater."

Bob's current projects include photographing a story on Malta for the *National Geographic* and a hardcover photo book about life at the U.S. Military Academy at West Point. He lives in Leonia, New Jersey, with his wife Peggy and their three sons.

Covering an entire country for a *National Geographic* story is one of the most challenging and sometimes overwhelming assignments a photographer can land. To capture the personality of a country—its people, geography, industry, culture, and wildlife—in twenty or so pictures of *Geographic* caliber is the ultimate location job. While I knew a bit of what I was getting into from previous experience on another *Geographic* assignment, the four months, and over 400 rolls of film it took me to cover the remote country of Iceland, held countless surprises and learning experiences.

The first step in any job like this is research. You've got to learn as much as you can about the destination you're covering *before* you leave. In the case of Iceland, this was no easy matter, since the bookstore shelves are not exactly overflowing with information on this tiny country. But no one at the *Geographic* will give you a shot list. You have to dig up your own photo situations, which means you've got to be as much of a journalist as a photographer.

I checked old *Geographics* and *Geo* magazines, both the English and German versions, and found them to be very helpful. Then, armed with a letter of introduction from the *Geographic*, I visited both the Icelandic consulate and the tourist board offices in New York. From the people there, I was able to get a list of contact names for the various areas and subjects I wanted to cover— the fishing industry, agriculture, and government, among others. One of the nice things about Iceland, I was beginning to find, is that everyone seems to know everyone else; not too surprising when you consider that the population of the entire country is only about 240,000. So I had gotten a pretty good working list of contacts, and I hadn't even left New York.

The next step was to determine what kind and how much equipment to take. Since, on a *Geographic* assignment, you encounter a wide range of situations from formal strobe portraits of the country's president to macroshots of fauna to aerials and all kinds of weather, it pays to be prepared for just about anything. I suspected that Reykjavík, the capital city, was not going to be awash in well-stocked camera stores so I had best bring everything along.

I don't ordinarily shoot any more than two motorized single-lens reflex camera bodies at one time but allowing for breakage and damage in the field, I took along five, plus two rangefinder bodies, a Polaroid SX-70, and a Nikonos (for foul weather, not underwater). I also brought 10 lenses, ranging from a 16mm full-frame fisheye to a 400mm lens with a 1.4× converter. In addition, I took three 200 watt second battery-operated strobes, a tripod and assorted lightstands, umbrellas, clamps, cords, plastic bags, batteries, small tape recorder for captions, a Polaroid back for my SLRs, and two handheld meters, usable for both available light and flash. I was ready for anything, which means of course, according to one of the corollaries of Murphy's Law, that I wouldn't end up needing two thirds of what I brought.

This is Reykjavík from the air.

This iceberg lagoon called Jokulsarlon is near an outlet glacier called Breidermerderjokull.

A young girl and boy on a farm in southern Iceland are bathed in the warm light of the midsummer midnight sun.

Film was another consideration. The *Geographic* recommends taking along all that you think you'll need since it can be tricky shipping film into foreign countries because of customs and duties. I brought 400 rolls of Kodachrome 64, plus 20 or so rolls of Ektachrome 400, along with Polaroid, and shipping cartons to send the film back to Washington. Combine all of the above with special clothing needs such as rubber boots, rainsuits, and heavy parkas, and you have a pretty good idea why my overweight baggage charge was much more than the price of my New York to Reykjavík ticket.

Since I had done a fair amount of homework before I left, I was lucky enough not to run into the "now that I'm here what do I do" syndrome that hits some people when they arrive, on site, for a *Geographic* assignment. In addition to my contact list, I had developed a working shot list, dividing my coverage into categories such as industry, agriculture, geography, culture, government, social problems, festivals, and people. This may sound a bit formulaic, but it helps you keep track of what you're doing in trying to present a well-rounded portrait of the country.

I had also scheduled my arrival so I could cover Icelandic Independence Day, a big public event like our July 4th. So besides spending the first few days tracking down contacts, I was able to ease into my assignment by shooting something colorful, accessible, and fairly easy.

Previous experience had taught me to place great importance on getting good, knowledgeable, local help. In most foreign locations, you need this help to get past the obvious, touristic shots and into something deeper. In addition, the actual traveling conditions in Iceland, where roads run the gamut from terrible to non-existent and you need a four wheel drive vehicle just to get out of your driveway, necessitated some help.

Sometimes you can go through an entire assignment never finding a decent guide and other times you get lucky. Fortunately, it was the latter for me when I was introduced (by a friend of a friend from the New York tourist office!) to Ellert Sigurdsson. Not only was he a certified guide with an encyclopedic knowledge of Iceland and her people, but he had a

highly developed knack of knowing the kinds of things and characters I was looking for. He could also handle a 4WD like nobody's business—maneuvering us through flooded glacial rivers, rugged moraines, and steep mountainsides with skill.

So when Ellert and I visited the volcanic regions of Lake Mývatn in the north of Iceland, not only did we photograph the spectacular geothermal landscapes, but we also found the offbeat people so beloved by *Geographic* editors, such as a woman who baked bread simply by burying it in the superheated ground.

Ellert would read to me from the

local papers, and from that we would track down any events or people who were interesting and making the local news. Whenever I traveled with Ellert, I found that I was able to get more work done, much more easily. But he had a lot of other guide commitments, so I was often on my own.

Death brings life to the volcanic island Surtsey that was formed in the early '60s by a series of volcanic eruptions. Plant life is beginning to take hold in the barren ashes, aided by decomposing organic matter like this bird.

Ofaerfoss is a waterfall situated on a tectonic rift in southern Iceland.

A solitary farm sits in a snow-covered landscape north of Akvreyri, near the Arctic Circle.

Here is a view of the boiling solfataras at Namaskard, a geothermal area in northern Iceland.

One of the unique Icelandic activities I wanted to photograph was the summer puffin hunting, which is centered in the rugged and remote Westmann Islands off Iceland's southern coast. Every year, the men of the main island, Heimaey, climb the cliffs of the surrounding uninhabited islands, set up camp, and collect these seabirds, which are then smoked and eaten as a seasonal delicacy.

This seemed relatively straightforward to me and it turned out to be easy to arrange. I flew from the mainland to Heimaey, where I was met by Páll Helgasson, the man who can arrange anything in the Westmanns. Páll's son Hrap was going to take me over to Bjarnarey in the family's 30 foot launch, where I would meet Hlödver Johnsen, the King of the Puffin Hunters. On the way to the harbor, Páll told me of an approaching storm. "It's not too bad," he said reassuringly. "But this is the North Atlantic and you may find it a bit choppy." As soon as Hrap and I left the protection of the harbor, I saw immediately that Páll's idea of "choppy" was different from mine. My idea of "choppy" is just that, "choppy,"

and his idea of "choppy" is vicious 10 to 12 foot seas and driving rain. Half of the time, the foredeck was underwater, and the other half I was holding on so I wouldn't slip off the stern. Without trying to appear too terrified, I remarked several times to Hrap that if he wanted to turn back it was okay with me. But, like a dedicated postal worker, he seemed determined to deliver his cargo, come rain, sleet, tidal waves or whatever.

It took us almost one hour to make the 1.2 mile journey, by which time I was soaked, seasick, and shaken by the sight of the 100 yard high cliffs which still lay between me and my puffin hunter pictures. Hrap maneuvered into the leeward side of the island, where the ascent path was alleged to be very easy. "It is so simple to get up from there," Hrap assured me, "even a cow could do it." I jumped from the boat to the flat rocks and turned to Hrap, who waved and yelled, "Just go up the rope."

At six foot two, two hundred and thirty pounds, I was neither born to run nor climb, yet I have scrambled up my fair share of embankments to

get a good picture. But the sheer cliff and the skinny rope that faced me was above and beyond the call of any duty, even the *National Geographic*'s. I wondered again briefly about the curious difference in definitions there seemed to be between the Icelandic and English language, because if Icelandic cows could climb this cliff, they must have wings. I was drenched, nauseous, despondent, and considering a career change into accounting or some other equally sedentary field when I heard the words "Welcome to Bjarnarey."

Hlödver Johnsen had sent down his assistant, Elias, a strapping Westmann Island youth, to assist me in the climb. Slowly, painstakingly, we made our way up the cliff, lashed together by a thick rope. It wasn't quite as bad a climb as it first seemed and there were several flat areas along the way to rest, but I tried not to think about the fact that if I fell, it was far more likely that I'd just take Elias along with me than it was that he would stop the fall by pulling on the rope. But aside from a few scraped knuckles and banged knees, the climb was uneventful.

In the evening, Hlödver Johnsen prepared a meal of smoked puffin while the storm winds battered the walls of his hut. Late the next day, when I had had my fill of both puffins and puffin pictures, I asked Hlödver to radio Hrap to pick me up. The Westmann Islands festival was going to start the following day on Heimaey, and I had made previous arrangements to meet *Geographic* writer Louise Levathes to cover the event.

Whether Hrap's radio wasn't on, or Hlödver's radio wasn't working properly I'll never know, but Hlödver couldn't reach Hrap. Elias, who had a pretty good idea of a) how scared I was on the trip over and b) how much I wanted to get the hell back to civilization, volunteered to take me because he himself wanted to take part in the festival revelry.

Hlödver kept an inflatable 10 foot rubber dinghy on the island which Elias assured me was much better suited to the rough seas than Hrap's sightseeing launch. I tried to believe him, but quite frankly, at that point I was just as ready to die then, in a small boat as the next day, in a larger one. After securely wrapping my two cameras and four lenses in a triple layer of plastic garbage bags, Elias and I climbed down the rope.

When we arrived at the cliff base, the waves were bigger and meaner than they were two days before and the dinghy looked pitifully small. The boat's one saving grace was its powerful outboard. When we clambered in, I assumed Elias would head straight for Heimaey, but instead he turned further around, heading straight to the leeward side of the island. "We must pick up the birds," Elias explained in answer to my quizzical look.

Way up on the top of the cliff, Hlödver began tossing rings of ten birds tied together. They floated gracefully through the air, and landed on the water with a loud crack, like the report of a powerful rifle. It was my job to pull the birds into the boat while Elias's task lay in preventing the waves from smashing us to smithereens against the cliff side.

After a half hour, I had pulled in some 600 or 700 birds, and Elias gunned the big engine, and roared into the heaving seas. This time, the waves were coming from behind and

we were literally flying from wave top to wave top, with the previously taciturn Elias whooping and howling like a banshee the whole time, while I, waist deep in dead puffins, was holding on for dear life. Every so often our timing was off, and we'd fly down and smack the boat on the trough of a big wave and it would break right over us. This was white-knuckle terror at its best, and when I yelled over the engine noise to Elias about putting on life vests I couldn't

believe I was hearing his answer correctly. "Don't have them," I thought I heard him yell. "We need the space for the birds."

I've never been one for grand gestures but when we docked in Heimaey, I came pretty close to kissing the brine-soaked wharf. Later that night I met up with writer Levathes at the hotel and told her of my adventures with Hlödver and company. Louise was intrigued and wanted to meet him.

Hlödver Johnsen, the king of the puffin hunters, turned out to be a real find.

The next day, the storm passed and the weather was fine. The opening of the festival was scheduled for later that night and by coincidence, Iceland's only rental helicopter showed up in Heimaey for the festival. Louise contracted with the pilot to take her to Bjarnarey for the afternoon. She took a two minute ride, landed outside the door of Hlödver's hut, spent the day with him, and returned in time for the festival opening that evening.

Depending on your point of view, this illustrates one of two things: either photographers are correct when they say writers have it easy, or writers are actually justified in thinking that they are so much smarter than photographers.

Speaking of helicopters, one of the toughest things about the Iceland assignment was arranging for aerial photos. Because the helicopter was much in demand around the country, you had to reserve in advance. Unfortunately, the Icelandic weather hardly cooperates on schedule, so I was reduced to calling around Iceland, trying to find the helicopter when nice weather arrived. I had

found a couple of skilled fixed-wing pilots as well, but they were also hard to pin down.

Although I got some nice aerial shots, one thing I had wanted to do was to shoot a small plane juxtaposed against the magnificent landscape from a helicopter hovering above it. But I could never line up the weather and both pilots at the same time—when one was available, the other was, inevitably, clear across the country.

Helicoptering in Iceland is real frontier flying. Ellie Haldersson, the dashing pilot, has 400 lb drums of A-1 jet fuel stashed in farms around the country. To refuel on some of our longer trips, we'd jerry-rig a ramp to stack two drums one on top of the other, and using a garden hose, we'd siphon the fuel into the chopper. Jet fuel, by the way, tastes no better than regular unleaded.

After the Westmann Islands trip, about midway through the assignment, I was feeling a bit sorry for myself. I had shipped over 200 rolls of exposed film and had not yet seen a frame. If you want a good definition of high anxiety, it is that

feeling you get when you ship raw film to a magazine where, at any given moment, 50 or 60 of the world's best photographers are also shipping theirs.

The *Geographic's* film review department, to their eternal credit, is very sensitive to this and will give you a written telex roll-by-roll breakdown of what worked and what didn't for each of your 25 roll shipments. I was getting good report cards, but nothing beats actually seeing your results.

So I was a bit depressed when I trudged back into my Reykjavík hotel one afternoon. I was also surprised to find the lobby redecorated in wall to wall Halliburton cases. There were beautiful model-type women flitting among the cases and production assistants barking nasal orders at anyone who would listen. The hotel

Thirty seconds after it appeared over the harbor in Heimaey, this rainbow was gone. But meanwhile I had shot a roll of film, and I knew I had a winner, even by Geographic *standards.*

manager grabbed me and steered me into the dining room. "There's someone I want you to meet," she winked.

Sitting placidly amidst the turmoil, dapper in a Khaki bush jacket, was the celebrated English photographer Norman Parkinson.

"*National Geographic*," said the manager, "meet *Town and Country*".

I was very nervous meeting one of the big names in the business face to face. But Parkinson was charming and waved me to a seat.

"Ah, *National Geographic*," he mused. "They send you somewhere for six months and forget about you. Good job, that. At least," he said gesturing toward his crew members now moving the Halliburton cases into the hotel's elevator, "you are left alone. A fortnight at ƒ/5.6 for each situation. Sounds jolly good!"

I left the dining room feeling rejuvenated and very lucky indeed.

The bulk of the assignment went very well. Most Icelanders were very eager to cooperate. Among the good picture situations I encountered was covering the annual sheep roundups. Every fall the entire rural population of Iceland heads into the mountains to retrieve the 1,500,000 sheep which were put out to summer pasture. The two week event culminates when herds of thousands of sheep are driven into huge circular pens surrounded by smaller wedge-shaped holding areas. Farmers wade through the sea of sheep and pick out theirs by identifying marks cut into the sheep's ear. Each farm has its own "wedged" holding area and when all the sheep have been sorted and identified, a new batch is brought in. Shooting this event from the air enabled me to capture true Icelandic cooperation.

I flew high above the annual sheep roundups and shot down over the pens, playing on the patterns and getting a series of shots that looked like sheep-covered pizzas. It was different enough to pass muster and a pretty good picture in its own right.

The Geographic *sees so many sheep pictures from all over the world that it's a standing joke down there, "Don't shoot sheep unless you can do something different." Backlit sheep, cute kids holding sheep, sheep on mountain cliffs . . . they've seen it all.*

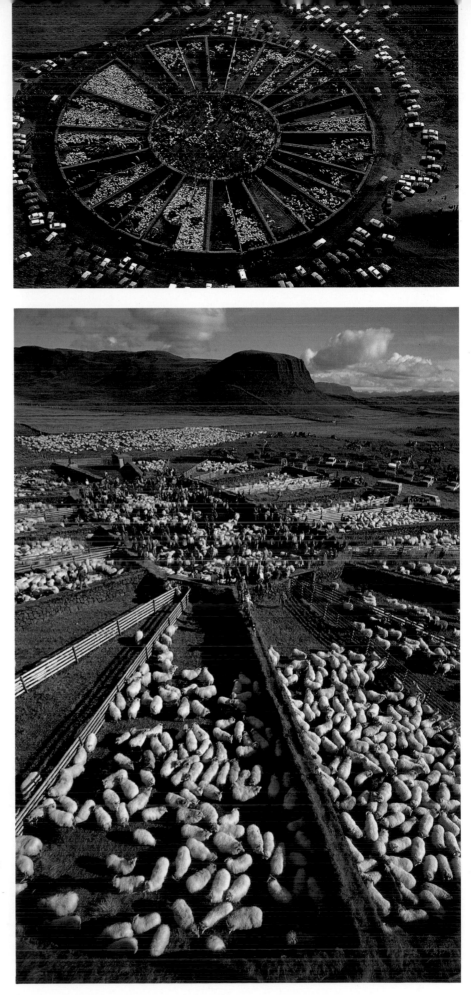

In Iceland's remote Western Fjords, a 90-year-old woman and her 91-year-old brother pose in the living room of their small farm. They both still work the land and were among the last people to leave Hornfjordur, a super-remote area that was inhabited until World War II but then abandoned.

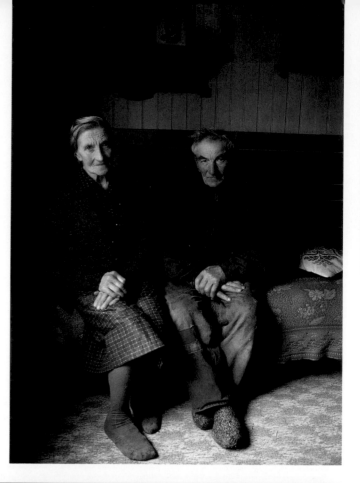

In addition to publishing his poems and tending to his farm, this old hermit poet was a priest in the old Norse religion, complete with a cult following and a statue of the Norse god Thor in his back barnyard.

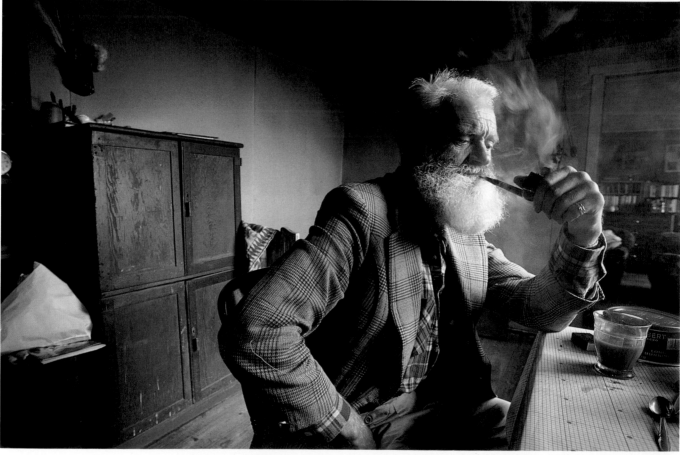

A small summer cottage near the outskirts of Reykjavík stands coated in snow and unused during the winter.

One thing that was constantly eluding me was a good picture of the fishing industry. Fishing accounts for nearly 80 percent of Iceland's economy and I really wanted to get the definitive fishing shot.

But modern fishing doesn't lend itself well to pictures. You don't get those rugged fisherman-knee-deep-in-cod type of shots. On modern trawlers, fish are scooped up and slapped into iced trays deep in the hold of the ship. I spent over three days on one such trawler in the Western Fjords of Iceland. After the first haul, two hours into the trip, I realized that there were not going to be too many worthwhile shots. It's very disappointing to realize early on that you've got to put up with cramped quarters, rough seas, bad food and surly shipmates for three whole days without a hope of getting the shot you want.

I went out on a few smaller boats, and still didn't get what I wanted. Finally, after much searching and questioning of fishermen, someone told me that the kind of fishing I was looking for did exist, "They do it in the winter," he explained, "on small boats based in the Westmann Islands."

The very sound of those words made my knees go weak.

At the end of the summer, after three-and-a-half months on location, my picture editor and I reviewed the take down in Washington. All in all, he was pretty satisfied with the coverage. "All you really need," he told me, "is a couple of winter street scenes and a decent fishing picture."

My brief return to Iceland in February went very smoothly. Ellert and I were combing the country, looking for snow. It's ironic, but Iceland was having its mildest winter in some 60 years, and there was more snow in New York than anywhere in Iceland. We finally ran into some snowstorms in the extreme north of Iceland, near the Arctic Circle.

All during this trip one thing had been haunting me: I was going to have to go back to the Westmann Islands and not only that, I was going to have to get out on the water again, or not get my fishing picture.

Páll Helgasson met me at the airport. We drove to the wharf and I took a look at the *Gullborg*. She was a 160 ton drift-netter, all wood, one of the oldest and best kept boats in the Westmann fleet. And, her captain told me, during a net pull the decks would be covered in fish. We planned to leave at 5:00 the next morning, weather permitting.

I literally did not sleep a wink that night. My nerves were ragged as I watched the clock edge toward 5:00 AM and saw the rains begin. I took the seasickness prevention tablets Páll had very kindly left for me and headed for the ship.

You wouldn't expect a 160 ton ship to toss as violently as a 12 ton launch but that's just what the *Gullborg* did as soon as we left harbor. It was clear that I was in for a 24 hour replay of my last Westmann voyage. Equally clear was the fact that Páll's seasickness pills were not working.

The six-man crew hauled in a net

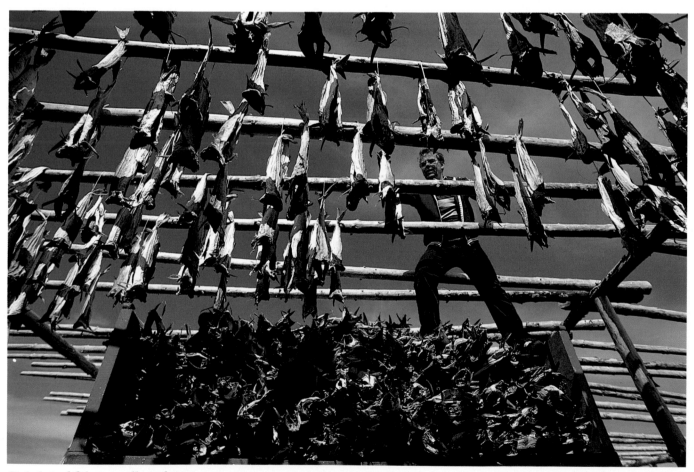

Dried stockfish are collected near Grindavík for export to Southern Europe and Africa.

laden with cod. They slit the throats of the fish and tossed them into holding boxes on deck. After the net was completely pulled in, crew members cleaned the fish and sent them into the hold to be packed in boxes of ice.

At one point, right near the end of each net pull, the men were knee deep in a deck full of fish. There was my shot, right in front of me!

I tried to shoot every net pull during the daylight hours. Sometimes, I just couldn't get up from the bunk or off the rail and so I missed some really good pulls I was told. When I did shoot, I just prefocused my 18mm lens and worked one-handed, while the other hand grabbed on to whatever wasn't sliding across the deck. The sea, as far as I was concerned, had lost all its romance.

I didn't bother to shoot during the night. I just laid in the tiny bunk, trying to ignore the mixed smell of diesel and fish and willing the morning to come. We pulled into Heimaey just before dawn. There were clear skies to the east while in the west, the black storm clouds were still hanging on. The harbor was full of boats, most of them having come in the previous night, but a few were straggling in behind us.

My first instinct upon hitting shore was to head for a shower and some sleep—I had only slept six hours in the last forty-eight. But instead, I just wandered the dock area. There was something weird about the sky, a combination of one half black clouds and the other half, clear. I photographed some boats unloading, but this wasn't the shot I was looking for.

A half hour later the sun rose and I knew what I had been waiting for. The whole harbor glowed golden, the sunlit boats taking on a super-saturated color in relief against the black storm clouds. Soaring above it all was a rainbow. It was an incredible scene, and I shot like crazy, working on autopilot at this point.

I headed for the guest house and remembered what my old man used to tell me when I was a second string varsity basketball player trying to make the starting five in high school. His advice didn't help much in my hoops career, but it's sure as hell applicable to location photography: "The harder you work, the luckier you get. . . ."

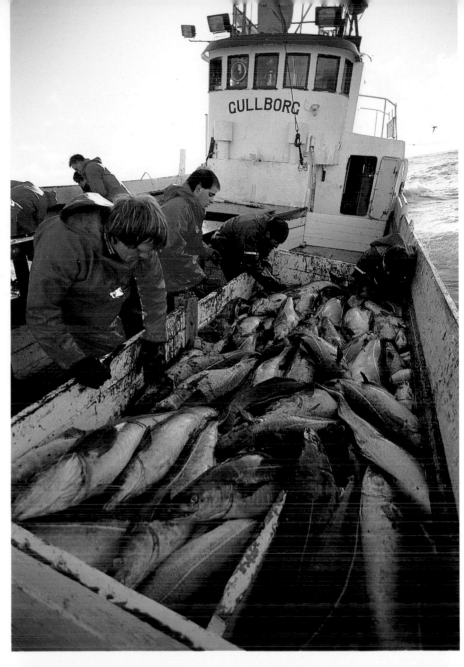

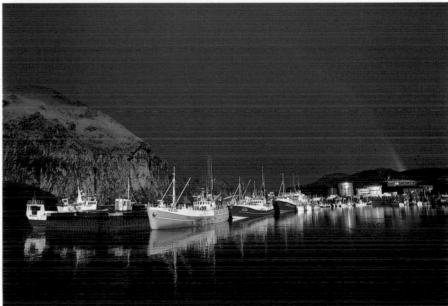

PURSUING THE POSITIVE

A relatively recent acquaintance, Michael Melford has become a friend. I had admired several of his takes for other clients, and after a review of his sample tray, I was eager to assign him and thought he would be the right person to photograph a Shaker village in New England. With his affinity for architecture and his meticulous composition and craftsmanship, I felt that visually he could readily enter the elegantly disciplined dimensions of their buildings and worldly goods.

Melford's research for the *Travel & Leisure* story, aside from some acquaintance with reproductions of their crafts, consisted of several visits to the Whitney Museum of American Art in New York City to see an exhibition called "Shaker Design," which ran from May 29–August 31, 1986. The tools, furniture, baskets, graphics, and other Shaker artifacts that he saw there provided him with rich inspiration about the "gift to be simple."

His assignment was to capture the essence of this simplicity, not in a museum setting, but in the Shaker villages in Maine, Vermont, and New Hampshire. Melford's construction work in his student days gave him insights into Shaker architecture and building methods as well as an affinity for all kinds of architecture.

He feels his basic visual sense comes from his study of Zen Buddhism. On the Shaker assignment he found his Zen principles coalesced with a lot of Shaker ethics and their esthetic.

Melford managed to light and compose the Shaker interiors in a way that seems totally appropriate and in character with the rooms and the people. The strict geometry of the interiors in his photographs are mellowed by a warm glow of light. The restrained but surprising colors of the Shaker palette are set off by their spare, serene architecture. There is life in these interiors even when no one is present.

In Melford's portraits of Shaker craftspeople and elders, he shows the same restraint. The people seem to flow into the design of the rooms, and they look as if they were from another time.

The final layouts for the Shaker story were carefully crafted. Lines within one photograph jumped across the page to align with elements in another photograph. The Shaker design ethic (including their typography) dictated, in a most benign way, the final form of the pages. Melford's visual ability to "think Shaker" allowed *Travel & Leisure* the opportunity to create a layout of rare graphic unity and to convey the essence of their cloistered communities in purely visual terms.

In his photographs of the Shakers, Melford lovingly captured this vanishing sect with their beautiful logic all around them in everyday use. Melford has made them *his* Shakers, and has thus conveyed their simple philosophy to us.

Michael Melford

ichael Melford was born in Gloversville, New York in 1950. He attended Syracuse University where he studied engineering. He had wanted to study photojournalism, but during his interview to gain admission to the School of Journalism, he said he didn't think it was possible for a photographer to be objective. He said that, as a photographer, he would react subjectively and photograph what he wanted to photograph, looking for things that others didn't see. He was thus denied admission to the School of Journalism and access to their photographic equipment.

As a result of the 1968 student strikes, some special students were permitted to develop their own curricula. Melford qualified and took courses in Moog synthesizer, music appreciation, film animation, art history, and photography. He put off all his freshman requirements and pursued his own degree program graduating with straight As and a 4.0 average.

At graduation, his professors encouraged Melford to go to New York; they asserted he would be the youngest photographer to get a cover of *Life* magazine based on his work at Syracuse. He went.

He lasted two weeks. He'd been naive enough to believe those tales of glory. He met Mel Scott at *Time, Inc.* who'd served with Melford's father in World War II. Scott pulled out a photographer's loup to look more closely at Melford's transparencies. Melford was stunned. Until then no one had wanted to look at his photographs *that* closely. Scott said, "You may be good in five years. Come back then and look me up."

Melford left New York for Colorado and carpentry, drifted to California, and applied to Brooks Institute of Photography in Santa Barbara. At first they rejected him based on his transcripts from Syracuse: "He is a free spirit. But if he believes in something he'll go out on a limb for it. Not very good with authority." He was eventually admitted.

In time, he moved back to New York City. He managed to get an assistant's job with Frederick Orringer, a theater photographer whose studio gave Melford a course in the *business* of photography as well as a place to work. Melford assisted Orringer on an annual-report shoot for Morgan Stanley and his work was accidentally noticed by the art director. Soon he was shooting ten annual reports a year.

After salting away a nest egg, Melford realized he needed to broaden his market to keep his work exciting. He sought and received assignments from *Geo* (U.S.), *Life* (Mel Scott finally gave him an assignment), *Travel & Leisure*, and other magazines.

Recently, his work has been a satisfying mix of about five annual reports a year and editorial assignments.

I shoot on location as opposed to in the studio because location photography really lets me experience every aspect of life: for instance, I get to fly with test pilots in F-16s, ride horses, and drive race cars. I couldn't do all these things if I were only shooting in a studio. And I don't have the measured temperament needed for studio photography. On location, I feel like I'm getting a front-row seat to see life. It's like having a press pass to do the things that I'm paid to do, things that I would otherwise pay for just to experience.

Quite honestly, location shoots are a lot of fun. I don't have any trouble putting in long hours, because I'm not only capturing something on film, I'm living it, too. When I'm having fun, I don't want to stop. That's what's nice about getting up, shooting at dawn, and just going all day long.

I generally try not to shoot between the hours of 10:00 AM and 4:00 PM because I find the light is simply too harsh. If you're shooting people, midday light puts shadows all across their faces, which isn't at all flattering. In landscapes, midday light turns the shadows black, unless you start using a mixture of electronic flash with daylight—then you can achieve some interesting effects.

I have a tendency to stay away from using strobes on location, but when I do use them, I try not to use too many lights outside. I like to go with pure natural light when I'm shooting on location. Natural light reveals so much, I really don't have to add anything artificial. If I do set up a situation with lights outside, it's really well planned. I make a lighting test with Polaroids the day before the actual shoot. When I know what I want, I come back and set it up the next day.

I don't use electronic flash on the camera the way a journalist might do. When I shoot at the optimum times— sunrise, sunset, presunrise, postsunset—occasionally I use flash, but never spontaneously; I never walk around with a flash on my camera and shoot that way.

I did recently use strobe lighting on a shoot for *Travel & Leisure* in Jackson Hole, Wyoming. I was shooting a scene at sunset with the sky in the background. After the sun had set, the sky turned a deep blue, and I made the shot by strobing a model in the

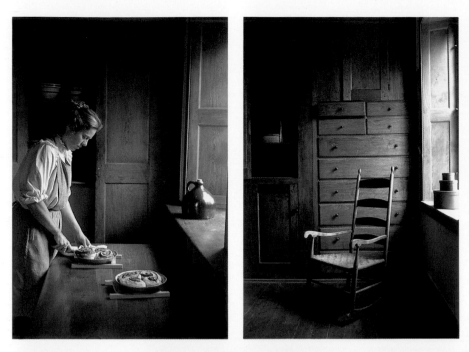

foreground and time-exposing the background. But I had been shooting there the day before and had realized it would be a much better photograph if a model were flash lit in the foreground, so I went back and set it up. When I use strobes, it's usually in such a situation; without them I work very fast because the light changes quickly early in the morning and late afternoon.

The way that I try to approach my subjects is to become one of them. If I'm photographing a test pilot, I go

out and become a fighter jock for two weeks. I try to capture their viewpoint and photograph their world the way they see it.

When *Travel & Leisure* assigned me to cover the Shakers, a religious sect with an ascetic communal life-style, I went to Hancock Shaker Village in Pittsfield, Massachusetts, and for two weeks I became a Shaker. Everything I saw was very simple. I wanted to reflect the Shakers' world view by making photographs the way they would if they could.

Basically, I feel the Shakers' perspective on life is reflected in everything that they make, so I chose to photograph the fruits of their labors. They were easy subjects to photograph because their handwork is so simply presented—all I had to do was point the camera. If I didn't crop my shots correctly, I knew the art director certainly would. The Shaker assignment was an all-win situation. I felt very lucky because it was my first assignment for *Travel & Leisure*, and I came out smelling like a rose.

A lot of the photographs that I make of people and large groups of people are set-up situations that I try to enliven with something comical or humorous. Otherwise, these people shots are simply boring pictures that we've all seen a million times. In addition to hard work, one of the key elements in making a photograph interesting is making it different. Throwing something into a photo that doesn't belong there hopefully jars a viewer's expectations enough to stop,

look at it, and say, "Now, *that* is interesting."

My location work is an equal combination of three things: talent, hard work, and luck. The combination of those three things creates successful shoots and successful careers. And I've been very lucky up to this point. I work really hard, so a little talent goes a long way.

I don't really have the kind of style that encourages a viewer to look at one of my photographs and say, "Oh, that's a Michael Melford." Partly because I like shooting such a variety of subjects, and partly because I like to blend into the situations I photograph, I don't want to approach every shoot with the same look. I want each one to look different, so I customize my style of photography according to the subject. It's hard to do that. I know one photographer who always uses a graduated filter, so if you see a brown sky in a photograph, you know it's his. Another photographer always puts a stocking over the lens and pushes the

film three stops. I don't use those kinds of stylistic tricks.

If there is anything in my work that could be constructed as a theme, it is that I only like to photograph positive things. Life is full of a lot of misery, and the newspapers are always filled with bad news. I like all of my photographs and all of my stories to be upbeat, happy, and humorous. Even if I'm working with a serious subject, I like it to display some life and a little love. That's the way I see life, and that's the way I shoot it.

An old guru of mine, Henri Cartier-Bresson (who never gave interviews to anyone, or very rarely), said he tried to make photographs that said, "Yes! Yes! Yes!" That's an affirmation of life that photography makes possible. You can do anything with photographs—you can make them very depressing or you can fill them with hope. I try to make people feel good about what they're looking at, and consequently about life and themselves. My photography is a positive thing.

CAPTURING
EVENTS

As a photojournalist, Eli Reed is often asked to cover events that are in the process of unfolding and to capture the newsworthy elements of a story. But when Bob Dannin, the editorial director at Magnum Photos, sent him down to Haiti to cover the departure of "Baby Doc" Duvalier, Reed found his main concern was to document the citizenry of Haiti in the throes of revolution. Although he did shoot pictures of the presidential palace and the guards, he discovered that the real drama was elsewhere—in the streets and in the houses of the people; it was the mood of the revolution itself, the emotional release after the long reign of dictatorship. The poverty and despair of Haiti's people were almost momentarily transcended by the downfall of a tyrant. Reed's assignment, then, was to show the revolution in *human* terms, instead of the official circuses directing it.

Reed's agency, Magnum Photos, is a cooperative consortium of photojournalists. The agency fulfills a linguistic role for the photographers by completing the equation between raw film and the printed story. Magnum Photos provides a wide range of services for a select number of photographers. The agency captions photos for content, categorizes them as to form and sequences them for impact, sense and story line. It also brokers the saleable commodity (the edited, captioned story) to a worldwide market, and recovers the photographs after publication. Magnum maintains a library/archive of individual images and markets these images for single uses in magazines, newspapers, and for exhibitions and fine art outlets.

The agency advises the photographers on how (and where and when) to best invest their time. Much of the work Magnum photographers do is speculative. The agency's responsibility is to find real markets for intelligently speculative stories. Magnum also acts as a legal agent, negotiating contracts with clients and determining terms of copyright. Furthermore, it is, in effect, the bookkeeper for the photographers and its own staff; as a cooperative venture, Magnum determines the division of profit to staff personnel at year-end. And the agency serves as an economic base for its photographer members.

Part of its ongoing business is to determine the need for renewal of stock images—providing continuity by subject and by photographer. For example, if Philip Jones Griffiths hasn't covered Beirut lately, the agency will schedule him for a trip to update Magnum's coverage and to bring Griffiths up-to-date on the place as well.

Bob Dannin starts his day reading newspapers and magazines from all over the world, from *The New York Times, Washington Post,* and London *Times* to *Liberation, Le Monde, Corriere de la Serra,* Frankfurter *Allegemein,* the Far Eastern *Economic Review,* and *Jeune Afrique* to name a few. Dannin immerses himself in these sources much as a stockbroker would hound *The Wall Street Journal,* the Dow, or other economic yardsticks and indicators. These worldwide news purveyors are his photographers' markets, and his clients. And they provide the clues to world events-in-the-making and the next assignments for his talented photojournalists.

Few agencies in the United States perform so many functions. Most simply represent photographers for specific assignments, maintain stock libraries, actively promote their photographers, and take a percentage of their earnings.

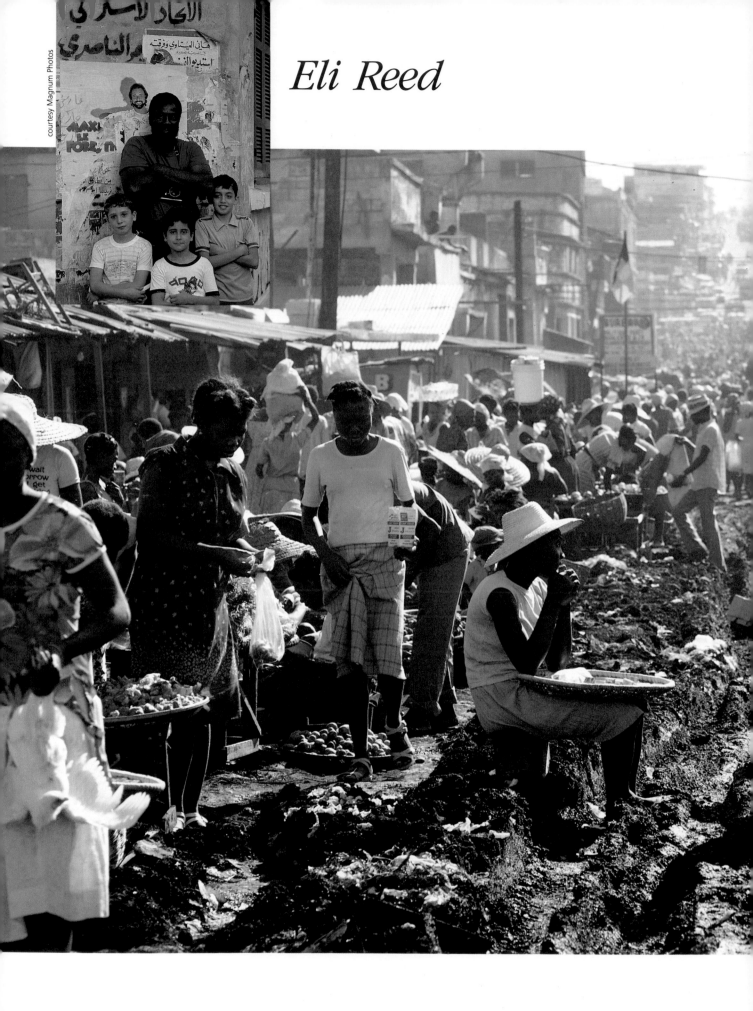

Eli Reed

A photographer who covers combat situations or political hotspots is advised to be short, slender, pale, and scared.

Eli Reed is none of these. He stands 6 feet 6 inches tall, weighs around 240 pounds, and his deceptive affability seems his only armor against the hostile worlds in which he works.

Born in Linden, New Jersey in 1946, he graduated from the Newark School of Fine and Industrial Arts in 1969 where he studied pictorial illustration. He began working at the *Middletown Times Herald Record* in Middletown, New York. He joined the *Detroit News* in Detroit, Michigan in 1978, where he covered the 1980 presidential campaign, prostitution, and Michigan prisons. He began working for the *San Francisco Examiner* in San Francisco in 1980 and covered in-depth stories such as nuclear blockades and urban life in black ghetto areas. He also shot a four-month project on Central America in the countries of El Salvador, Guatemala, Honduras, Nicaragua, and Costa Rica.

In 1982, he received a Nieman Fellowship from Harvard University and a second place Pulitzer Prize for his photo essay in 1981 on the "Pink Palace," a low-income housing project in San Francisco. He was also given an Overseas Press Club Award in 1983 for best photoreporting for newspapers and wire services, and the Nikon World Understanding Award (sponsored by the Missouri School of Journalism and National Press Photographers Association) for work done in Central America.

Reed's photographs have been published in magazines such as *Life*, *Time*, *People*, *New York Magazine*, *Newsweek*, *Vogue*, *Health*, *Mother Jones*, *Fortune*, *Forbes*, *Sports Illustrated* and many others.

He spent four months covering Beirut, Lebanon during 1983–84, documenting the effects of long term civil war on the inhabitants, and most recently he covered the upheaval in Haiti.

Among the books that have included his work are *El Salvador: The Work of Thirty Photographers* (1983), *War Torn* (1984), *The Black Photographer*: Volume Three, *One Moment of the World* (*Photo Vision*; Volumes Two and Three). He has participated in four of the "Day in the Life of" projects—Hawaii, Canada, Japan, and America.

Reed's work has been featured in international photographic magazines such as *American Photographer*, *French Photo*, *Camera 35*, and *NewLook*. He has lectured on and exhibited his work extensively.

A W. Eugene Smith Memorial Grant finalist in the years 1983 and 1986, Reed joined Magnum Photos, the international photo cooperative, in 1983, and became an associate member in June 1985.

I went to Haiti because something was happening down there, and the people at Magnum Photos knew it. Bob Dannin likes to stay on top of what's happening in the world, and he knows where the hot spots are going to be. Bob had been keeping in touch with Danny Lyon, a photojournalist and filmmaker who had been traveling back and forth to Haiti shooting black and white film. They both knew the turmoil in Haiti was building to the point where the people were going to rebel against Jean Claude Duvalier, Haiti's President for Life, better known as "Baby Doc."

Magnum sent three photographers to cover the rebellion: Danny Lyon, Gilles Peress (Magnum's president), and myself. Peress was busy photographing in Europe, and we decided to wait for him to return. Then it seemed as if we had blown it—rumor had it that Baby Doc had already left the country, and we had no one there to cover the story. But it turned out he hadn't—no country would take him.

Danny Lyon flew to Haiti with Clarence Elie, a freelance researcher whose main function was to whisper in Danny's ear, "Shoot color, shoot color." Magazines today want color, not black and white. While Danny was there, the unrest in Haiti really blew up—people began burning Port-au-Prince. Bob Dannin had a lot of magazines to service with pictures, so he sent me down to Haiti right away, even though I didn't really have an assignment. This story couldn't wait.

I took a flight from New York to Florida where I joined Gilles Peress. The airport in Port-au-Prince had been closed, but somehow a flight from Miami was still scheduled to take off. It was such a strange scene— I ran into a lot of journalists I knew, and they didn't seem to understand what was going on either. However, we did finally board the plane, even though we didn't know what we were getting into or what to expect once we landed.

For a lot of these journalists, Haiti was a poor man's Philippines. They couldn't afford to fly to the Philippines to cover the ongoing revolt against Ferdinand Marcos, and the reporters who couldn't make it there weren't given that assignment. So going to Haiti was their big chance to cover a Third World revolution.

Of course, just because Baby Doc and Marcos are now gone doesn't mean that the corruption that is built into both countries' systems has disappeared. It's not over in Haiti, and it's not over in the Philippines. The serious problems that continue, the ones I focused on in my pictures of Haiti, are something people don't want to think about. The news on TV gives the public happy endings, and they think that's it and cut to the titles. Meanwhile the struggle continues; the story doesn't end when the assignment is over.

Seeing this band playing at the airport was my first view of Haiti.

This artist sells his paintings at the beach.

Farmers grow sugarcane and potatoes just outside Port-au-Prince.

There were rumors that an airborne army division might parachute into Port-au-Prince, which is where I saw these two soldiers.

I took this shot while looking for a place where I might be able to spot any parachute troops.

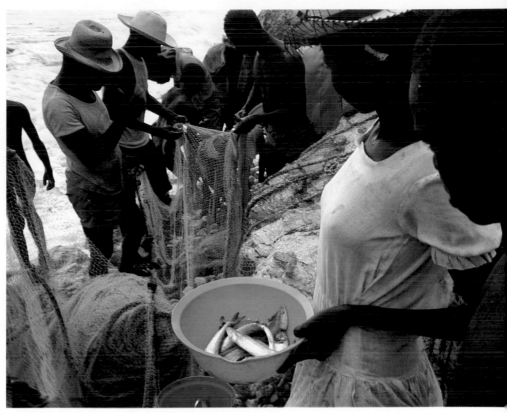

These people were fishing in a small town outside of Port-au-Prince.

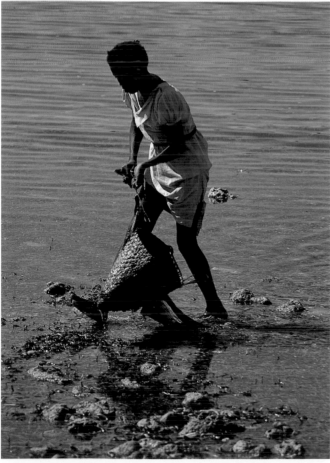

A girl and her brother fishing for my lunch at a waterfront restaurant.

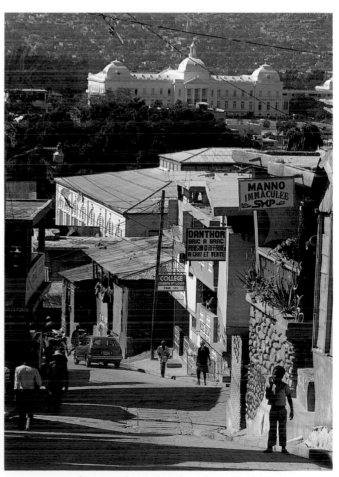

You can see the presidential palace looming in the background here.

We arrived in Port-au-Prince on a Sunday afternoon. Danny's assistant, Clarence, who is part Haitian, met us at the airport with a friend. I can speak a little French—I studied it for a year in high school. But I'm the kind of person who likes to concentrate on nonverbal clues—I'm always looking for visual information. A lot of times what is being said has nothing to do with the body language or the reality of a situation. Sometimes it works to my advantage if I don't speak the language. Then, like an *idiot savant*, I can just work through the visual messages I'm picking up. For instance, the first thing I saw coming off the plane was a few guys making music at the airport as if nothing was going on. I thought that was strange, but it gave me a clue about things to come.

I spent about 10 days in Haiti trying to make sense of a seriously complicated situation. I saw people literally starving in the streets. One of the first things I saw was a kid skinning a cat—he was going to eat it. He apparently had skinned many cats many times before and was very skilled at it. (Later on, back in New York I ran into a Haitian cab driver who told me that skinning cats is something only kids on drugs do. I tried to tell him the kid had not been high, but the cabbie hadn't been home for 19 years; maybe he'd forgotten what life there is really like.)

People began to celebrate like crazy a long time before Baby Doc's departure, which was good to see. Everyone started coming down to the palace. When the new junta took over, I was there. It wasn't a big deal to switch between shooting the official and the unofficial moments. I was more or less always doing deep background photography—I was trying to photograph the reasons *why* people were doing what they were doing. I knew what was happening was history in the making.

I consciously decided not to shoot color for color's sake. I was very aware of Haiti's beauty, and it's so easy to go for the easy shot, to be seduced by the color. Instead, I focused my instincts on what was actually happening, so I ended up showing Haiti with all the scars. This was a case of following my gut feeling all the way without letting any other considerations interfere.

This is a poor family. The girl in the back is a pregnant teenager. Their poverty is amazing, but they do their best to keep things clean in a really difficult situation.

The boy on the left with the Sergio Valente T-shirt is a smart, beautiful little kid with a lilting voice. Most Haitians are very competitive, but I never saw this boy competing because he was just so sure of himself. A bigger kid, who was trying to get work as a guide, wanted to get rid of this little kid because he spoke three different languages.

The room this family lives in is about eight feet square, and about six people live in it. It's a hard life for all of them, from the father to the newborn baby

A Catholic relief agency was passing out food to these kids, who were deranged with hunger. Clarence, Tony, and I had to run for our lives right after I took this picture because the Tonton Macoutes came after us with their Uzis. A crazy chase ensued through the barrio. Luckily, we escaped, but only because the barrio is as confusing as a rabbit warren.

The Tonton Macoutes used to dump bodies in this hole after torturing people at their headquarters in Grasseria.

This man was still selling pictures of Baby Doc on the day he left the country. Obviously, the vendor didn't know that Baby Doc had gone. Maybe he was friends with the Tonton Macoutes, who knows? I wanted to shoot this picture in black and white, but I barely had time to get it in color. The guy wanted me to pay him to do it, but I didn't want to do that.

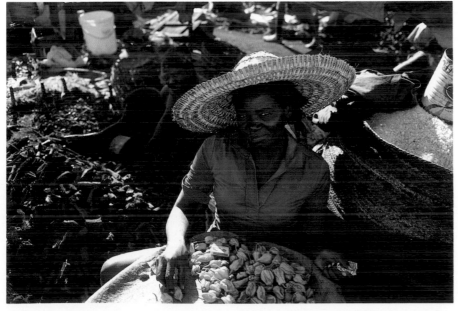

This is the big market in Port-au-Prince, and it is horrible. It's filthy dirty, and people sell stuff that you can see was packed right there.

This boy has a copy of the semi-official local newspaper.

As a news photographer, you've got to go in there right to the wall—you can't stop yourself before you start. Part of training yourself is to constantly evaluate whether or not you've gone far enough or sometimes too far. You can't relax. If you do, you're going to come out with a lot of boring pictures.

While I was there, I never felt like I was doing enough. Every day I went to bed late and woke up early. I was really leery about eating because I have a very sensitive stomach, and I know how easy it is to get sick. At one point outside Port-au-Prince we stopped at a waterfront restaurant at Clarence's suggestion. After we'd ordered some fish and had been sitting there awhile, I started wondering what was taking so long; we were the only customers there. Clarence pointed outdoors and said, "See the guy out there in the water? He's catching your dinner."

A 14-year-old girl and her brother were in the water fishing. When she came out of the water, it was like seeing pure Haitian innocence, unself-conscious but malnourished. She was a blithe little spirit, really beautiful. But you can't escape from the problems in Haiti, you keep getting reminded. Most of the Haitian diet is fish. A tourist came in and said, "Oh, it's so lovely to see that girl and her brother out there fishing." Well, it hit home that they were starving, too.

I wanted to contrast the physical beauty of Haiti on the one hand, against the offensive reality and surrealism of the revolt on the other. The beautiful hotels, the great weather, and the tourists were still there. I met a woman who owns property in Haiti and who had friends in the Duvalier family. She thought that it was all a misunderstanding and that nothing could really go wrong. For people like her, the revolt became an adventure, an attitude she could afford because she never went anywhere near where it was dangerous.

The Tonton Macoutes—the so-called *Volunteers for National Security*—were still desperately trying to put down the rebellion. They were Baby Doc's bully boys, the boogeymen he left behind, very sinister guys. After the junta took over, they decided not to allow any journalists into the countryside—everyone had to stay in the city. I kept hearing stories about the Tonton Macoutes gunning people down outside the city with machine guns, but I figured maybe I could disguise myself. I talked over a plan with Gilles Peress about going into the countryside with a camera and a couple of lenses in a paper bag. I was going to try to take a bus, but I didn't get out after all. No one was being allowed to go anywhere.

Some of the hotels had Tonton Macoutes working part-time as security guards. I noticed one of them right away, the first day I arrived. He happened to have been on the same plane from Miami as I was. I had heard that Baby Doc had spies in Miami who brought back reports on the people there. This guy took an interest in me, which I wasn't crazy about. On my very first night there, he and three uniformed associates in a car came rolling up to the hotel entrance, just as I was about to cross the street with Clarence to go look at the stars by the water. As they pulled up in front of me, I could see their Uzi machine guns on the car floor. The Tonton Macoute from the plane said something in French, and one of the other guys interpreted, "He wants to know who you are."

This was psychological warfare, and I rose to the challenge. "Oh, hi," I said. "How you doing? I'm Eli Reed from Magnum Photos. How are you?" I startled the hell out of him— nobody asks the Tonton Macoutes how they are.

"I'm Mr. Tonton Macoute," he said.

"Oh, that's nice," I replied.

Then he drove off, and Clarence said, "Hey, don't mess with those guys." Well, what do I know? They had blue uniforms and guns. When I run into characters like that, I'll do whatever I can to throw them off.

When you're on an assignment like this one, you have to displace the negative stuff that comes at you. You have to be able to bring it down into terms you can deal with; then you can throw any threat to you off-balance and keep your concentration focused on what you came for. Shooting Haiti took the kind of discipline I have learned practicing Akido, one of the martial arts. You have to become one with what is happening, and then you have to let it float past you so you can observe it. You have to get into it, you have to be touched by it, but at the same time you deflect it. Looking at these pictures now, I'm not as disgusted as I was earlier.

This guy is tearing up his identification papers. He'd just been hit in the mouth with a gun.

Afterwards, he tore up some pictures of Papa Doc Duvalier.

A soldier is warning people to stay away.

Somebody had just taken this policeman's gun. I saw it disappear, but it happened too fast to photograph.

There were a lot of people at this church service due to the problems that were going on that day. People were really frightened.

I took this picture the day before the Duvaliers left. The next day the people ripped down the Duvalier family crypt. They took the body out and ripped it apart.

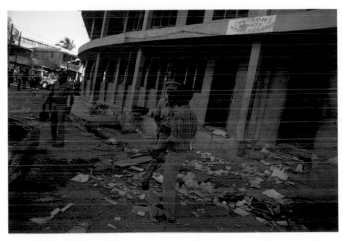

The police were dangerous, but the man on the right kept taunting them. One of the police just didn't have time for it; I was waiting for him to start shooting.

The man with the big smile is holding a pocket from a Tonton Macoute shirt.

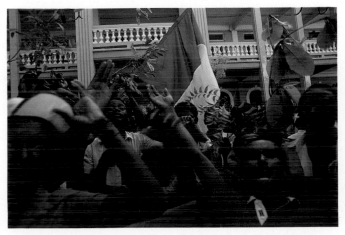

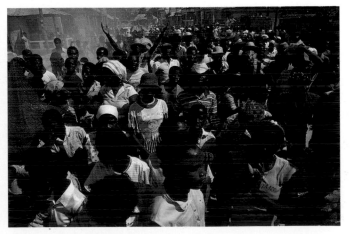

A day or two after Baby Doc left, there was a carnival outside of Port-au-Prince.

This small town outside Port-au-Prince held a Catholic mass, and then they had a little celebration, not an official carnival.

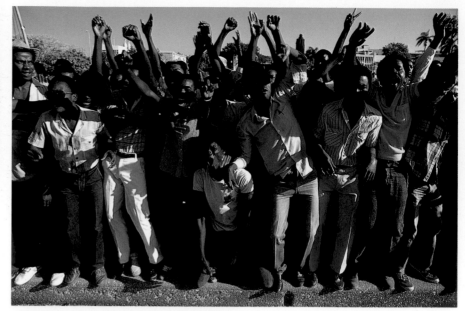

Despite the fact that they were fighting off the old regime with sticks and stones, people were cheering. I heard that some were getting gunned down by helicopter gunships, and that's why I wanted to get to the presidential palace to record this scene.

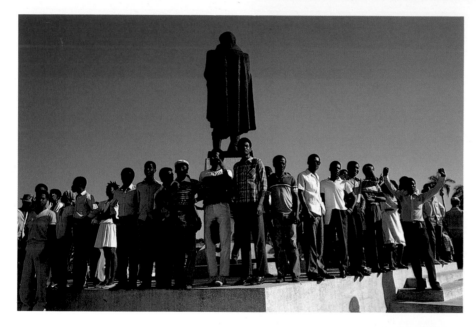

I shot this crowd across from the palace on the day the radio announced that Baby Doc had left.

The man in the middle of the front row, third from the left, is Namphy. He was essentially the leader of the junta. The two civilians in the front row were part of the new government. The new regime is still related to the old. Namphy has a good reputation. On first hearing his speeches, the people felt giddy because he had pushed Baby Doc out of Haiti. I felt sorry for Namphy because I knew he didn't have the necessary skills to handle the problems.

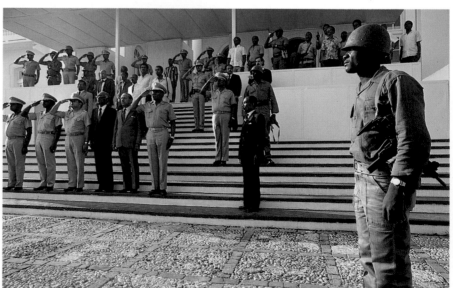

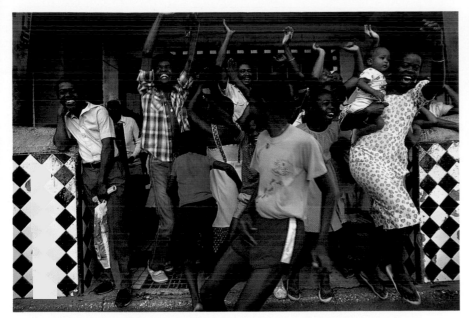

Somebody drove a dummy of a Tonton Macoute around, and the crowds thought it was funny as hell— they got a big kick out of it.

I love this picture of people celebrating. How exciting it was! Before the rebellion, there was a lot of tension, and people were afraid to talk at night.

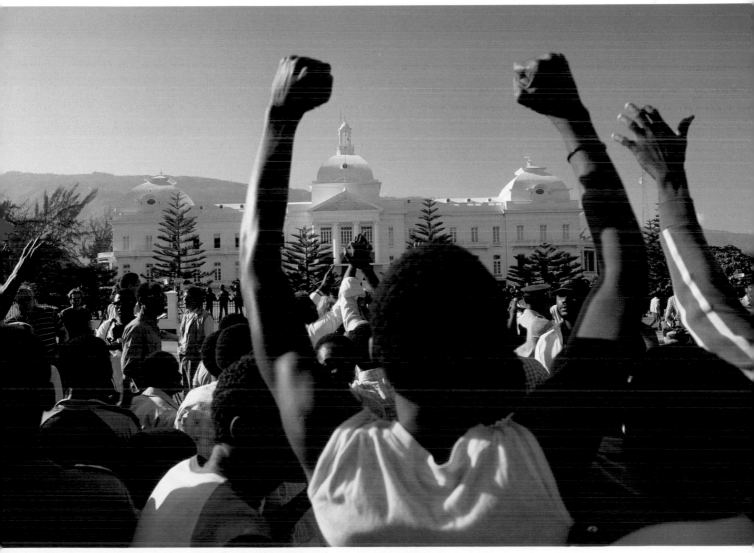

A jubilant crowd gathered outside the presidential palace.

SHOOTING TO A LAYOUT

Advertising photography on location can be as freewheeling as an editorial shoot, but it's more than likely that an advertising assignment will be based on a tightly conceived, preplanned, and preapproved layout that the photographer is expected to fulfill exactly. In fact, there are many times when the location shoot for advertising is as restrictive as shooting in the studio—with added logistical problems thrown in for good measure.

Not only will the visual layout of the ad have gone through an arduous series of approvals, but within that layout will be headlines and other forms of type that the photographer will have to accommodate. There may also be other photographs to be stripped in and retouched later. The photographer and the location crew must keep all of these elements in mind, shooting precisely to the layout, making sure that the angle is exactly as needed, the light source is from the proper side, and that the areas where the type will fall have the right tonality. It's often as complex as trying to maintain continuity in a motion picture.

In addition to the arduous preplanning, the final shots must again be approved—by the art director, copywriter, creative director, account executive, client ad-director, and sometimes even the CEO of a Fortune 500 company. (Compare this to editorial precincts, where you must meet the approval of the picture editor, art director, and a couple of editors, at most.)

Jake Rajs's shoots for Ogilvy & Mather (advertising agency for the American Express Company) perhaps typify what a location assignment for advertising can be. The layouts had been carefully designed to require certain moods and viewpoints, and potential risks were inherent in each situation.

It was Rajs's job to find places that met the requirements. Thousands of air miles, hundreds of phone calls, letters, official permissions, and releases were needed to finally zero in on the precise spots that worked. This difficulty of fitting a photograph to a preconceived layout, the "precision of vision" required, may not be the only reason that advertising photographers are paid more than editorial photographers, but it certainly is *one* reason.

Jake Rajs

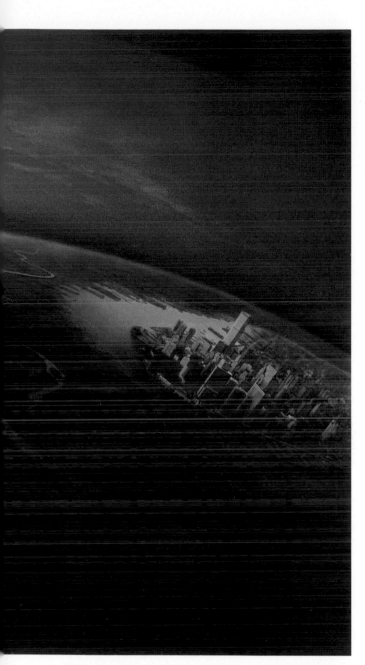

Jake Rajs arrived in New York from Poland in 1960 at the age of eight. He grew up in Brooklyn and in New Brunswick, New Jersey.

At Rutgers College, New Brunswick, New Jersey, he began studying engineering, switched to an English major, and then moved on to the visual arts—painting, sculpture, and graphics. A glimmer of interest in photography began as he found painting to be too confining. He studied photography at Rutgers, and his work was included in a New Jersey photographers' group show.

In the restless, early seventies, he took off for Europe to sketch and paint. After returning to prepare a show of paintings, he drifted to Massachusetts to renovate mansions and paint the coastline in Manchester-by-the-Sea. He decided to return to New York to continue his artistic development.

Once he firmly decided on photography as a career choice, he never turned back. He combed the *Yellow Pages*, knocked on studio doors, called Hiro, Pete Turner, Jay Maisel, and Joe Morello, a still-life photographer. Joe hired him and gave him his first opportunity to learn some of the business of photography in a commercial environment, to learn about strobes and 5K banks and large-format equipment.

On the verge of succumbing to the lure of San Francisco, he heard about an assistant's job at Pete Turner's studio, went over, and got the job. He stayed with Turner for nine months, a gestation period that turned out to be a productive one.

A summer assisting Jay Maisel put some lustrous touches on Rajs's professional finish. Working for Maisel, he discovered the helicopter as a photographic tool.

From Turner and Maisel he acquired a strong sense of self-marketing and an understanding of the problems and opportunities photography, as a business, presents. Through his experience assisting them he gained expertise with the wide spectrum of photo equipment available and learned how to gain access to art directors.

After what seemed an endless chain of telephone calls and portfolio drop-offs to agencies and magazines, Rajs landed a job with *Esquire* illustrating an excerpt from the book *Sophie's Choice*; it was 1977, and he was on his way at last. Then his sale of some stock photographs for Grand Marnier ads brought him awards, exposure, and his first serious photographic income. Assignments quickly followed for Eurail, the "I Love New York" campaign, and Gulf and Exxon.

Other successes quickly followed. In 1985, Rizzoli published Rajs's stunning book, *Manhattan: An Island in Focus*.

The best advertising assignments (aside from those that allow the photographer complete freedom) are the ones where the photographer works in complete partnership with the art director. This campaign for American Express was just such a case: Grant Parrish, art director for Ogilvy & Mather (American Express Company's advertising agency), and I worked side by side for most of the assignment.

The rationale for the campaign grew out of Ogilvy & Mather's and American Express's desire to show the American Express Card as a global problem solver. Earlier campaigns had concentrated on the more standard retail uses for the card, such as department stores and restaurants.

They wanted to show places that were foreign, and perhaps a bit threatening to the traveler if he or she were stuck with no economic life-support systems—and to stress that the American Express Card provided a real help and reassurance in out-of-the-way places. "Ominous" was a key word that Parrish used in selling the campaign; the concept was one of problems and solutions.

The layouts were prepared and the ad copy written prior to my being called in on the job. Nature and man don't often contrive to form coincidence with an art director's layout, but photographers must and do. On an assignment such as this, scouting the right locations is 90 percent of the job.

Not every assignment allows such lead time for location searches, but here it was absolutely necessary. While Parrish and I worked together on this shoot, I also employed Ed Leach as a location scout. Although my studio is piled to the ceiling with boxes of file photos, I inevitably find myself starting from scratch. But I always shoot a lot on scouting trips, both for reference and just to capture what's there—you never know what will eventually be used.

There's also a lot of research to be done prior to a scouting trip. For example, in planning the shot of the runway for this campaign, Ed Leach and I spent many hours pouring through libraries, aviation magazines and Jepson guides for pilots. We talked to the FAA and other government agencies about airports to narrow down our search for the exact type of runway needed. Once the initial choices were made, we then had to travel to the various sites. After selecting what we considered to be the best site, permissions had to be secured and an exact time planned for the shoot. Timing and schedules are critical working in an airport.

Each of the locations for the American Express campaign were chosen for their exotic, distinctly "foreign" flavor, or for their "ominous" implications. It was Parrish's goal to avoid stereotypical "postcard" images, and yet capture the essence of a particular place or the mood of the situation in the final photograph.

The final ads are, of course, the result of a lot of teamwork. Printmakers and retouchers play a great part in the ultimate success of most advertising campaigns, as does consistent art direction. I don't mind this. For me, the ultimate satisfaction is seeing my photography become a basis for that success.

Grant Parrish was in London on a television shoot, and used the time to line up a crew of assistants. Big Ben seemed an apt choice to symbolize London, as did the distinctively red British phone box. A phone box was rented and placed in position. I controlled the lighting inside it via a sync to the camera. The wallet was placed in the scene, and the shot was taken.

The final ad consisted of one straight photograph with the exception of the wallet—it was enlarged slightly by means of a dye-transfer print and retouching.

I had originally wanted Big Ben to be dark in order to draw more attention to the phone box. However, when we discovered it would take two days to arrange to have the lights turned off, we decided to go with the situation as it was.

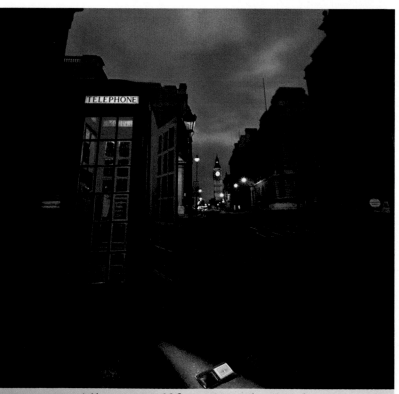

All you need if you lose the Card. Emergency replacement around the world.

No matter where or when in an emergency, you can get an American Express® Card replaced quickly. Usually within 24 hours. Sometimes it may be the next business day. But in any event, you'll be back on the road, fast. Because you can go to almost 1,000 of the Travel Service Offices of American Express Company, its subsidiaries and Representatives. They can also help with emergency funds. And assist you with other lost travel documents and tickets. No other card can do all this, this fast, in this many places. One more reason to carry the American Express Card. Don't leave home without it.

104

All you need when you need to straighten out your trip. In English.

AMERICAN EXPRESS
Travel Service

You need someone who not only understands English, but also someone who understands travel problems. And that's exactly who you will find at the nearly 1,000 Travel Service Offices of American Express Company, its subsidiaries and Representatives worldwide. They know how to untangle a snarled itinerary. To get you emergency funds with the Card. To replace a lost Card, fast. The only card with all the resources and people of American Express to help you at home and abroad. The American Express® Card. **Don't leave home without it.**

All you need to get emergency cash where they don't know you.

The Hong-Kong shoot proved how valuable a good guide can be in a foreign city. Confusion was the concept behind the ad, and a guide was hired to take us to the most garish and labyrinthine visual cacophony of neon Chinese signage available—we wanted a scene that would strike utter confusion in the heart of the most seasoned traveler.

We had brought along a 3 × 4 foot Plexiglas American-Express sign, and when Parrish and I felt that we had found the perfect block, I quickly secured the sign to a street post and placed a Sunpak 5000 strobe behind it.

I had to shoot quickly because a crowd was beginning to gather, but I didn't take a good look at the people around me until we were packing up the equipment. Parrish was finally taking a look around also, and he asked the driver where we were exactly. Only then did we find out I had just photographed the "combat zone," Hong Kong's infamous red-light district; the Chinese characters, when translated, made reference to girls and strip-dancing. Obviously, this was hardly in keeping with the American Express image.

So we went out again the next night, driver in tow, this time making sure that every sign visible in the new setting was translated for us before we set up the shot.

Grant Parrish typically gave me a very tight layout around which the shoots were planned. His vision for this campaign was so exacting that, as you can see by comparing the layout shown to the tear sheet above, there was little change from conception to finished ad.

Istanbul was our next stop. Prior to leaving New York, I had arranged for the Turkish consulate to provide a guide and driver. (It's my standard procedure to contact in advance the government office of any country where I'm going to be shooting; many times their personnel can be of great help.) In this instance, the driver was particularly helpful because Turkey was under a state of martial law at the time.

We knew the location we wanted—Parrish had sketched out a view of the old quarter of the city with the Galata bridge in the foreground—so all that was left to do was to find the right vantage point for the shoot. It seemed at first as if one of the minarets attached to the mosques would provide the best view. While these are usually off-limits to all but those of the Moslem faith, somehow our government guide got us access. Unfortunately, after all his trouble and tours of two dozen minaret towers, the best viewpoint came from the sixth-floor roof of a modern office building.

Parrish's sketch called for a lone taxi to make a predawn trip across the bridge, but taxis in Istanbul look rather like generic automobiles; there's nothing to distinguish them in the eyes of those looking at the final advertisement. Our driver graciously agreed to take a few hours off and make a sign for the top of his car, which could be lighted with a bulb and be more in keeping with the world's idea of a typical taxi.

Finally, we gained the cooperation of the soldiers manning the street corners around the bridge. For safety's sake, I thought it best to inform them the day before that we would be climbing out on the rooftop at 3:30 the next morning. For the price of a few Polaroid portraits to any soldiers who wanted them, they blocked off the streets surrounding the bridge, allowing our taxi driver a clear lane of traffic at the time of the shoot.

Incredibly, all the logistics were worked out in advance, and the shot went very smoothly. Parrish ended up moving a mosque a few inches in the final ad, which may have saved his layout, but probably not his soul from eternal Islamic damnation.

Not all the ads in this campaign were intended to imply "threat avoided." Some ads, such as this overview of the seventh green at Pebble Beach golf course, were meant to evoke the idea of "pleasure extended."

Parrish and I researched a number of golf courses across the country, but Pebble Beach offered the peninsular configuration we needed—and the club gave us permission to shoot there. (Our first choice had been the Cypress Point Golf Club, which had politely, but firmly, said no.)

I hired a helicopter and pilot in nearby Castroville, and we took off. It was late afternoon toward the end of summer, and I shot the foreground about 45 minutes before I took the background shot. Parrish wanted to drop the headline type out of the foreground, so I had to ensure the area would be dark enough to hold the type, without having the golfers too severely silhouetted. I shot the background later, again avoiding the deep silhouette, but including the flare of the sunset. The two shots were stripped together in the final ad.

When you want to stay
for 3 more sunsets, you've got it made.

You've got the Card.

When you want to stay for just a few more sunsets, you've got something that fits the bill.

You've got the Card.

As with all of the other ads, the copy had been written and approved beforehand, and the layout called for the busiest cloverleaf intersection possible, with linear interest and a large city rising like a veritable oasis in the background. We started our location search in the west, although the obvious Los Angeles/San Francisco cliché was to be avoided. After touring eleven cities in nine days, we arrived in Pittsburgh and found the magic combination we needed.

I worked from a fixed vantage point, shooting the city at sunset, and later using a time exposure to capture the trails of headlights on the freeway. The shot of the city was enlarged slightly in the final ad.

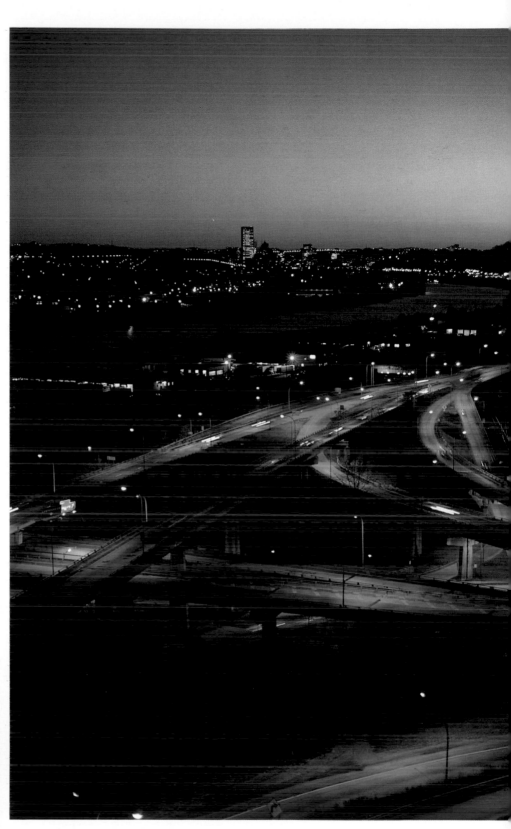

It seemed a bit ironic that a terrace at the Diner's Club headquarters provided the perfect vantage point to capture one of New York City's dark canyons, but with this type of shooting, when you find the right spot, you go with it.

The shot was set up for a very early Sunday morning, perhaps the only time you can count on so little traffic on the city's streets. The taxi was hired to stand by in front of the Helmsley Palace Hotel. I had put lights underneath the canopy to create a focal point, a welcoming glow in the blue-gray dawn. It's particularly nice that the spires of St. Patrick's Cathedral provide relief from the smooth steel and glass of the office towers.

This ad is the result of pure production, combined with a variety of locations chosen to meet a predetermined layout. The house is in Virginia (we needed large windows), the town is Massachusetts (we wanted a quintessential American setting), and the lighted interior was done in a studio in New York (I wanted controlled lighting). The Mercedes was parked outside the house in Virginia to add a hint of the "upscale lifestyle" befitting an American Express cardmember with a problem.

All three photographs were combined into one dye-transfer print that was retouched to hide the seams.

This ad was also produced in pieces as I worked with different locations that provided the right setting for each aspect of the shot. New York's Kennedy Airport was the setting for the "gridlock" of planes; I had actually shot this much earlier and it was the only stock photograph I used in the campaign. Newark Airport, which also serves the New York metropolitan area, permitted us to use space to set up lights and move the cart and bags around.

Once Parrish and I selected the final photographs, both images were combined into one dye-transfer print and retouched, asphalt to asphalt. Although the airline logos were omitted for obvious reasons, this ad was quickly pulled (although it was widely run) because of airline objections to the portrayal of lost luggage.

**You may never see your bags again.
But you can recover.**

You've got the Card.

Now there's no need to lose sleep over lost luggage. Stolen luggage. Or luggage that somehow gets mangled, flattened, crushed or cracked. Because you've got up to $1200 insurance on your baggage—and its contents—when you charge your travel tickets with the American Express® Card. You're covered while aboard any licensed common carrier–train, plane, boat or bus. And the insurance also covers certain carry-on items–like briefcases and cameras. Naturally, there are conditions and exclusions which apply.* But no other major charge card provides this world-wide service. What's more, baggage insurance is automatically provided when you charge your travel tickets with the Card. So from now on, lost luggage doesn't mean all is lost. Because you've got the American Express Card. **Don't leave home without it.®**

*For details, call 1-800-645-9700 or write: American Express Card Baggage Insurance Plan™, P.O. Box 311, Jericho, New York 11753. The Policy providing this coverage is on file at the offices of American Express Travel Related Services Company Inc., the Policyholder.

You know places to get cash,
even in places you don't know.

You've got the Card.

No matter where you land, you know where to get cash. Because with the American Express® Card, you can cash your personal checks at any participating hotel, motel, or airline. And you can also cash personal checks and get American Express® Travelers Cheques at any American Express Travel Service Office. Subject to some limits based on local regulations, cash availabilities and establishment policies.

And with the Card, once you've enrolled in the Express Cash program, you can get up to $500 a week at automated cash dispensers of participating financial institutions. Plus as much as $500 a week in cheques at American Express Travelers Cheque Dispensers. To enroll, call 1-800-CASH-NOW. Knowing how to get cash is as easy as knowing the right card to carry. **Don't leave home without it.**

Travel Service Offices of American Express Travel Related Services Company, Inc., its affiliates and Representatives.

When this ad ran, several airline pilots called American Express in confusion. The skyline is definitely Denver, and they recognized the runway, with its configuration of lights, compass heading, and designation. But Denver doesn't have a runway 10R aimed directly toward downtown—no way.

They were right, of course. The runway is in Portland, Oregon. I had shot the Denver airport while doing research for this ad but obviously not from an active runway. When it came down to the actual shoot, Portland was the only city with an acquiescent airport management and an unused runway (it was temporarily closed for repairs) where I could use a cherry picker without fear of low-flying aircraft. The cherry picker was raised to a height of 100 feet, the runway lights were turned on, and I used two 1000 halozer lights to illuminate the numbers.

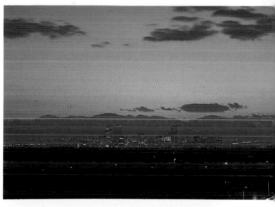

113

An earlier version of the layout for this ad carried the words, "coast to coast," but "the world" was substituted later. Grant Parrish envisioned San Francisco on one end of the spectrum, New York on the other, with believable landmarks in between: the Rockies, the heartland, and one river, at least. A logistical *tour de force for me, certainly, this was ultimately a retoucher's nightmare.*

Preplanning was important here because I had to allow for believable edges so that the retoucher had reasonable seams to strip together. We worked with six shots, starting in San Francisco and moving east to the Rockies, the Missouri River, and Manhattan and the Hudson River— all shot at sunset. One sunset was used for the entire sky, which was shot with a 16mm lens so that the arc of the horizon could serve as a common denominator.

The mountains were the fun part for a number of reasons. I got to shoot the Cascade Range in Washington State, Mount Hood in Oregon, the Sierra Nevadas in

California, the Rocky Mountains in Colorado, and my favorite mountains, the Tetons. I shot from a Cessna 182 airplane, with the window out, at 20,000 feet which amounted to a gulp of oxygen and then a quick shot followed by another gulp and then another shot. Also, I had always assumed that mountains just sort of trail off into the distance, but they don't—at least not in the places where you want them to. As I said, this was a retoucher's nightmare.

The rest of the shots involved the usual problem-solving: time of day, angle and altitude, and choice of lens. All in all, though, I will admit that this was one of my most challenging assignments to date.

The shooting itself covered two weeks, with an additional two weeks for pulling dye transfers and retouching. From concept to final client approval, it took three months. But with Parrish's faith that I could do the job, the talents of Belart the retoucher, and a shooting budget of $35,000, we took American Express successfully from coast to coast in a double-page spread.

When you take on the world, you're not alone.

You've got the Card that's welcomed at hotels, restaurants, fine shops, airlines, and car rentals–around town as well as around the world. But there's more to it than that. You've got the security of traveling with the Card that's backed by all the services and people of American Express.

Here's a brief description of some of the special services currently available to our American Express Cardmembers. If you have questions on details or restrictions, please don't hesitate: give us a call.

You've got no pre-set spending limit.

Many other cards have a pre-set limit; the American Express Card doesn't. Purchases are approved based on your ability to pay as demonstrated by your past spending, your payment patterns, and your personal resources. So you can take care of

unexpected emergencies or unexpected pleasures. In short, if you can handle it, the Card can handle it.

You've got Assured Reservations.®

You've got a way to make certain your hotel will hold your room no matter how late you arrive. And when you add Express Service, you've got fast hotel check-in

and check-out. If for some reason they can't hold your hotel room the hotel will pay for a room in a comparable hotel, transportation, and a phone call. If your plans should change, just telephone the hotel before 6 p.m. their time (4 p.m. at resorts); ask for and keep a cancellation number in case you are accidentally billed.

You've got emergency Card replacement.

You've got a way to get a lost or stolen Card replaced fast. Usually within 24 hours or by the end of the next business day. Just go to the nearest Travel Service Office.*

You've got nearly 1,000 Travel Service Offices.

American Express Travel Service Offices* are world-famous for helping travelers and especially Cardmembers. Expert

travel agents, they can help when you plan, arrange, and ticket your trip–business or vacation. Their emergency financial and travel help is legendary. In more than 120 countries, you're never alone.

You've got 24-hour American Express Travelers Cheque Dispensers.

Once you enroll, you can get $100 to $500 in Travelers Cheques, 365 days a year, at 80 automatic dispensers in U.S. airports, as well as some American Express Travel Service Offices in the U.S. and Canada.

You've got $75,000 Travel Accident Insurance.

Every time your tickets are charged on the Card, you, your spouse, and dependent children under 23 are automatically covered. It's included in your Cardmem-

bership at no extra cost. Underwritten by Fireman's Fund American Life Insurance Company, San Rafael, California.

You've got signed receipts.

A copy of most of the receipts you signed is enclosed with your monthly bill. So you can double-check your expense account or budget. There's even space to record the purpose of the expense, which is a great help at tax time.

You've got emergency check cashing.

When you're out of town and out of cash, you're not out of luck. You can get funds at participating hotels, motels, airlines, car rental counters, and American Express Travel Service Offices.* It ranges from $50 in emergency funds at many airline ticket counters to as much as $1,000

($200 in cash, the balance in American Express® Travelers Cheques) at Travel Service Offices, subject of course to local regulations and cash availability.

You've got customer service experts.

You've got human beings to talk to. They're experts on all of these services and many we haven't listed here. They're also expert troubleshooters if you have billing problems or questions. The phone number for your area is on your billing statement.

You've got to apply.

If you aren't already a Cardmember, call 800-528-8000, and we'll send you an application. You shouldn't have to take on the world all by yourself. The American Express Card. Don't leave home without it.®

You've got the Card.™

*Travel Service Offices of American Express Company, its subsidiaries and Representatives
© American Express Company, 1982

115

GOURMET
SPECIALTIES

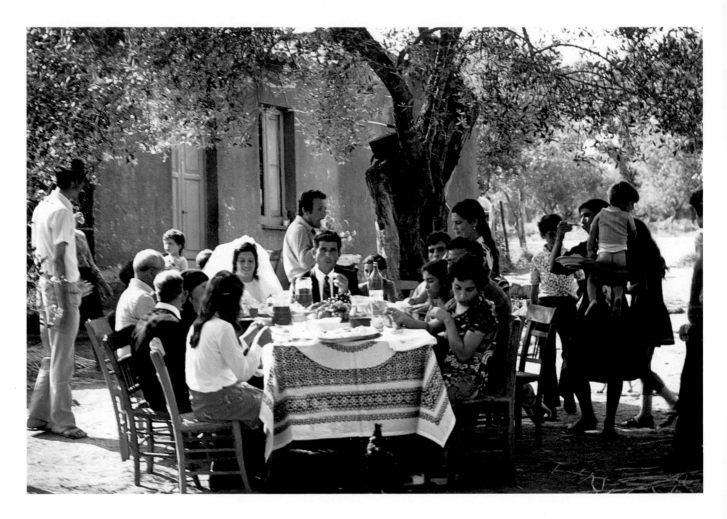

Food photography is sometimes considered a photographic specialization bordering on the mystical. Apart from the fact that usually a food specialist or stylist is needed to prepare the food and sometimes to "dress the set," or provide and arrange the tableware, crystal, linens, or whatever, food photography is really no different from shooting any other subject. However, the logistics of shooting food on location can become *very* complex, especially for advertising.

The photographs in *Gourmet* magazine are often simply actual meals in their original setting photographed at a particularly advantageous time of day. And for editorial use (and some enlightened advertisers) that's okay. In fact, the simplicity is often down-right marvelous—it seems real because it is.

But advertisers often insist on gnat's-eyelash perfection—not a hair out of place, especially in the soup. In the studio, perfection like this is very hard to achieve. But on location, the problems increase significantly. Keeping food hot, or cold, keeping lettuce fresh, peas shining, sorbet or brie from running, somewhere on an alp or on a sultry tropical beach obviously makes preplanning *critical*. And the photographer has to know when to say "Okay, that's it, let's shoot it."

Food photographers should possess faultless taste (pun slightly intended) in such matters as décor, suitability of accessories, and arrangement of food, linens, and candelabra. Stylists are also crucial to a successful food shoot, and they can either make or break it. Good food photographers usually have one or two favorite stylists with whom they have developed a rapport that at times can seem almost extrasensory.

Anthony Blake is a world-class food photographer who is as at home shooting a complex food shot in Bordeaux for a French ad as he is shooting a beer ad in Denmark. He uses many stylists regularly from several different countries. But once the set is ready, nobody touches it but Blake.

Blake uses stylists to *prepare* the food and to cook it properly. However, he feels the design, arrangement, and placement of the food in the photograph is very much his responsibility.

Unlike other food photographers, he never uses inedible additives or ingredients, such as glycerine, to keep moist food moist or fresh vegetables fresh. He uses Evian water in an atomizer, and if the set dies, he starts over. And he never has a problem with insects, mainly because he always has assistants standing by with flyswatters literally brushing them away.

Shooting food on location is the only way Blake feels anyone can credibly create the ambience of the time and place the food is eaten or prepared. He doesn't believe the light really can be duplicated in the studio if the set is supposed to represent a picnic outdoors. Perhaps that's why the greatest chefs in the world prefer to work with Anthony Blake.

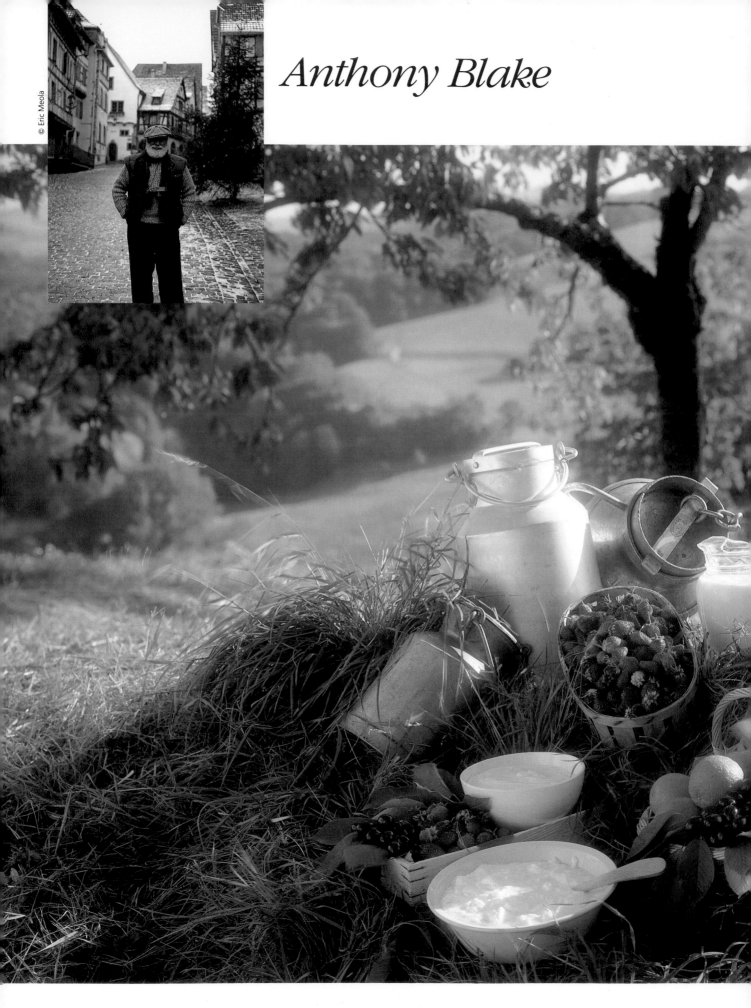

Anthony Blake

Anthony Blake has been eating and drinking since birth about 57 years ago. Before volunteering for the Royal Air Force in 1949, Blake spent some time farming in southwest England and developed a lasting interest in food and agriculture. During his five years of RAF service, he learned military photography: high-speed stills, high-speed cinematography, and public relations and aerial photography. In 1954, Blake left the RAF and set up his own photography business in the basement of his father's shop. He began by photographing pieces of mechanical and electrical equipment and he covered weddings and dinner dances as an assistant for other photographers.

He was practically on the verge of giving up and taking other employment when his assignments increased and he began covering location shoots on his own. He found he could cope with the difficulties, providing he established and adhered to a structured routine. In the mid- to late 50s, he opened his first studio, and entered the field of industrial photography.

Through this work he met Mr. Pryde-Hughes, who introduced him to some style editors for women's magazines. Blake began to make still-life shots of pots and pans for women's magazines, and he moved on to taking food pictures for them. As a result, he was approached by advertising agencies and started to shoot a lot of food, still lifes, and people for advertising.

In 1968 he visited New York to show his portfolio to Time-Life Books and was given a complete book to photograph, *The Cooking of the British Isles*, followed by other books in their "Food of the World" series. Then he was introduced to the French magazine *Marie Claire*, which led him to advertising work in France.

Through *Marie Claire* he met the French chef Paul Bocuse in 1976 and was given a commission to photograph the top French chefs for Mumm champagne. This campaign inspired him with an idea for a book, *The Great Chefs of France*. Blake spent 18 months on the project, self funded and self-produced. The book sold 80,000 copies.

Since then he has shot a lot of corporate advertising for banks, particularly Deutsche Bank, Morgan Guaranty, and F. van Landschott. His other book credits include: *American Cooking—Creole & Acadian; American Cooking—Southern Style; Cookery of the Pacific and Southeast Asia; The Times Calendar Cookbook*, with Katie Stewart; French, Chinese, Italian, and Indian menu guides for *Readers' Digest; New Classic Cuisine*, with the Roux Brothers; *The Southeast Asia Vegetarian Cookbook*; and *The Roux Brothers on Patisserie*.

For me, location shooting is almost the same as working in the studio. For the last ten years my work has nearly always been done on location, which really hasn't posed any problems. There is no way around professionalism. I have to consider every detail, whether it's in the studio or in the field. I work mostly with 35mm cameras and only occasionally in large formats. Sometimes I carry 4×5 and 8×10 cameras out in the field, but that requires stronger assistants.

I have first-class assistants, very able people who know how to work swiftly. (Four of my assistants have gone on to become professional photographers.) I have excellent back-up in my studio and my picture library, and my whole operation moves like clockwork. We often begin at 4:00 AM in order to get everything ready and begin shooting on time.

Wherever I go, a mountain of equipment goes with me in my four-wheel-drive Range Rover. I take along whatever I am likely to need at any moment, even generators if I think there's a possibility I'll need electricity. I usually know beforehand what I'll need, such as electronic flash and various kinds of lighting, but I always include a giant tool box as well, packed with such things as fuses, filters, clips, clamps, tape, air-blowers, things to make drinks fizzy, colorings, daylight filters, and artificial light filters. It would be easier to tell you what I *don't* take with me. In fact, when I go on location, the studio's usually pretty empty. What I bring outside is usually what I have inside.

I like mixing artificial light with daylight, mixing daylight and electronic flash, and bouncing light off reflectors. In short, I do anything to give me the result I want. It can be tricky to make each shot look like it had been shot with available light, and I don't want to give the impression that I've had to backlight, frontlight, or sidelight my subject. Though the scene may often be filled carefully with the extra lighting I've brought, I like people to think that it's as natural as it can get. It's important that everybody feel that the shot they see in the magazine is just the way they might imagine it would be if they'd walked out on the street and there it was, with no extra lighting, or artificial enhancer.

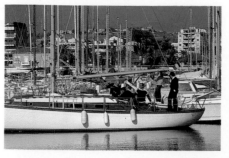
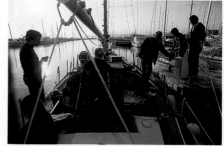
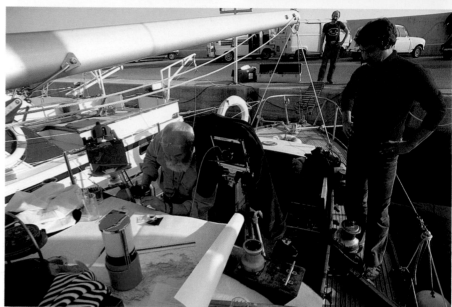

In Cannes, France, we had to bring a yacht across the harbor and dock the boat so I could capture the setting sun in this picture made to advertise the gas lamp in the foreground. It took us all day to position the boat and set up our equipment. The final image was shot about 10 to 15 minutes before the sun went down. Sunsets require speed and accuracy. If you don't get the shot right the first time, you're in real trouble—you have to wait another 24 hours for the same light.

That's my philosophy, to make the photograph look as natural as it possibly can. This doesn't mean that when a client comes to me and says he wants a particular effect that I will not do it—on the contrary, I will try to give him what he wants.

In pursuing a livelihood I try to be practical at times in order to have some time to progress with the work I really want to do. For instance, I have a picture library of stock photographs that I lease. Happily, I earn enough from my assignments to be able to go out and shoot specifically for the library. Although I may not make any money on the stock pictures that I shoot for up to six months or a year or more, these photographs become an ongoing investment. The investment is beginning now, after seven or eight years, to show a profit, partly as a result of a highly successful brochure put together in the last year. In Britain "profit" is sometimes considered a base word, but in America it's usually the key word.

In 1968, armed with a portfolio of five years' worth of work produced for a variety of British magazines and for myself, I came to New York City to show the New World what I could do. I went to advertising agencies at first. Then *Life* magazine was good enough to grant me an interview with a picture editor. The editor didn't think what I was doing was right for *Life*, but she very graciously passed me

along to the Time-Life book division, and there I met Dick Williams, who was then senior editor. After three meetings of showing my work there, they eventually said, "We would like you to do a book on cookery in the British Isles."

That was my first break. I had had the interview, but it was three months before anyone called me back. In the interim I returned to England and was getting more and more despondent. I thought, "Where's this wonderful book I am going to do, when will it happen?" And in three months they phoned me to say, "We'd like to see you again. Fly over to New York, and we'll give you a briefing and you can start."

For anyone coming from Britain in 1968, the opportunity to work for the Time-Life book division was most inspiring. Because their books were successful, they were able to give their photographers the support they needed. I had a year and three months to produce a whole book, and I had a wonderful time doing it. The opportunities this assignment afforded me were numerous, and though the pay was low (I received $5,000 for the outside work, and $5,000 for the studio work, and all my expenses were paid) I was totally wrapped up in it and felt that it was the greatest work-related experience I had ever had in my life. I've had a couple, but this really was different. I got at it and got into it.

We started putting this picture together on a hillside outside Lyons, France at 8:30 AM, but we didn't actually shoot this ad for Kronenbourg beer until 6:45 P.M. It was a beautiful day, and everything was just perfect when we finally made the shot. We had brought generators along, so I was able to use a little flash here. There was a very fine stylist on this assignment, a lady called Jillie Farraday who works out of Paris. She did a superb job.

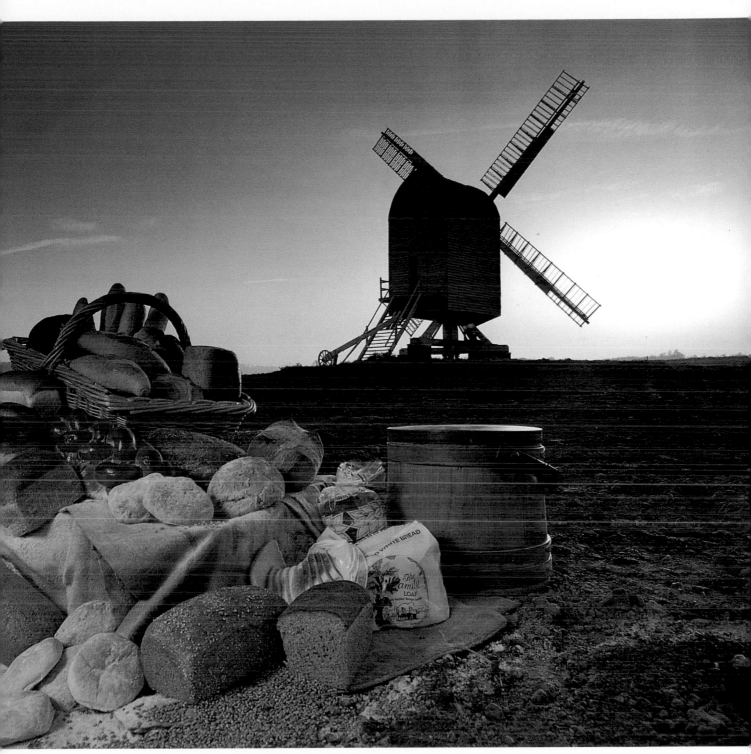

The London Sunday Times *gave me this assignment to illustrate a story about whole wheat and good foods.*

123

One of the craziest ads I shot involved bringing cows into a suburban "close," the British name for a cul-de-sac because the street is closed at one end. In Britain, milk is still delivered to the doorstep. The story behind this dairy campaign focused on the idea that, despite modern times, cows and milk were still only a step away. In fact, for this shoot we did have a herd of cows tied up at the end of the street from 9:00 AM until 8:00 PM. Doing the overhead shot from a crane was difficult, so we actually had a milking machine on hand in order to milk the cows if we had to stay overnight on location. Fortunately, I got the right shot just before sunset, as you can see by the long shadows in the final shot.

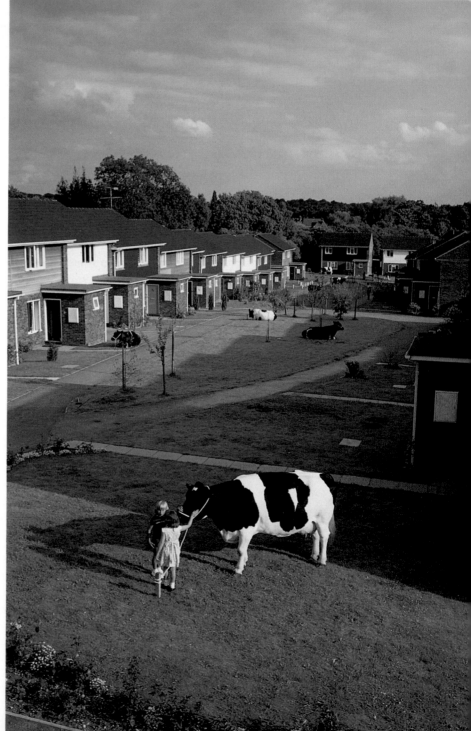

I shot this ad for Camping Gaz, an outdoor cooking fuel, in the south of France in early January or February. Finding enough green foliage for the background wasn't easy, but we did eventually find a good spot on top of a hill. It was extremely cold when we began setting up around 9:00 AM, but we had no real problems other than the time it took to carry the equipment uphill. This took a lot of people, too, so in addition to me and my assistant, we had a woman along to supervise all the transportation arrangements. I was shooting in 4×5, which meant that when 5:00 PM rolled around and the light was finally right, I had to know how quickly I could change my film and how many shots I could get before the light changed. If you have to climb to the top of a hill to make a photograph, believe me, you'd better be ready when the sun breaks through.

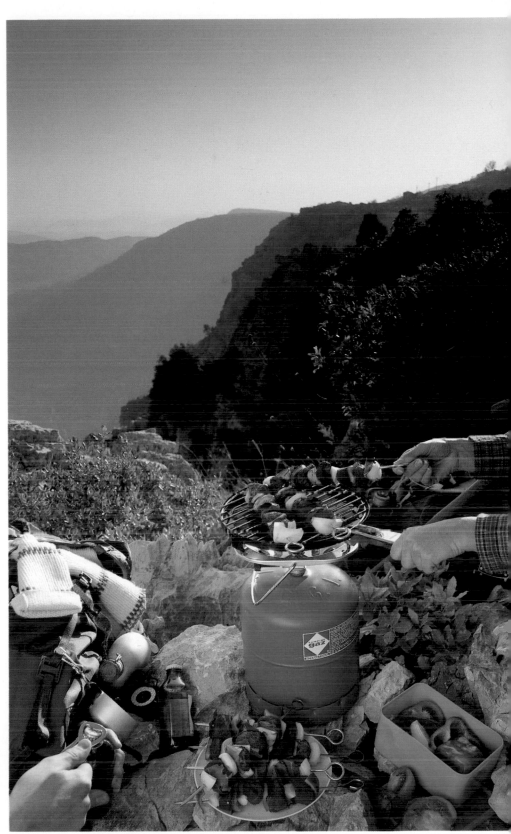

As you can see from the background shots, we constantly watched the way the light was changing after setting up this picnic shot with two kayaks. We were in a little valley where the light shone for only a short time each day. We set up, broke for lunch, and had just enough time to shoot in the late-afternoon light.

This ad for Camping Gaz was set up about 100 yards down river from the kayak picture. It was jolly difficult to get this second location, set up, and make this photograph by 4:45 PM while there was still enough light.

Working on the British cookery book opened up doors to working with many other people. I did four more books with Time-Life, including one on Creole/Acadian food shot on location and a book on the Pacific done in a studio in New York. I also did a piece on regional America, and a story on whiskey in Kentucky.

From there I went back to Europe and started food photography in earnest. It was terrific and I enjoyed it. In 1971 I went to Paris to photograph the world of food. My background with Time-Life was fine, but the French think that Americans know nothing about food and the British even less. They allowed me in through an art director I had been working with in London. I started working with one or two French advertising agencies. An agency called Impact had the Mumm champagne account, which became my next big opportunity. The Mumm campaign enabled me to photograph a dozen of the major restaurants in France, including six or seven of their best chefs. Then I started working with

Marie-Clare magazine, which was very proud of their food section. Although my ability to speak French was limited, with the help of wonderful stylists and assistants I got through. I was able to engender around me the enthusiasm that was necessary to successfully complete these assignments.

Shooting the Mumm champagne ads gave me the idea for *The Great Chefs of France*, a book that I started in 1976. It was something I felt I had to do. Many of the chefs who had become famous during the 70s were doing their own books. Paul Bocuse and eight or nine others had been awarded the Legion d'Honneur for their abilities. They held a dinner for Giscard d'Estaing and had all subsequently been given a medal and become celebrities in their own right. I realized after this that it would be a good idea to do a book about them all. I got on with them well, so I felt there would be no problems. I treated them as the stars that they certainly were, and they treated me well also because I was always

punctual, courteous, reliable, and professional throughout our working relationship. And most important, I did not disrupt their restaurants.

I put together *The Great Chefs of France* in two years. It was published worldwide and sold 80,000 copies. It's now out of print; however, it was a great boost to my career. As a consequence I still work with the best chefs. Though it got me into considerable debt at the time, it was worth it, because I still show that book to people and they know what I am able to accomplish. And pleasing an account like Mumm champagne gave me considerable joy and credit.

In recent years I've produced two other books with the Roux brothers, Michel and Albert (the only three-star Michelin chefs in Britain). I've traveled through Australia, Britain, America, Egypt, and all throughout Europe, mostly photographing food, but photographing other subjects as well. My work has carried me along in the best way I know—with good eating, good wine, good pictures, and a lot of fun and laughs.

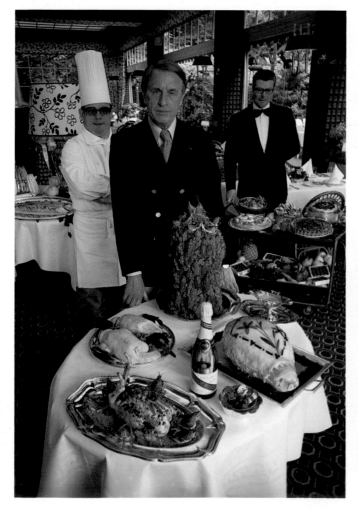

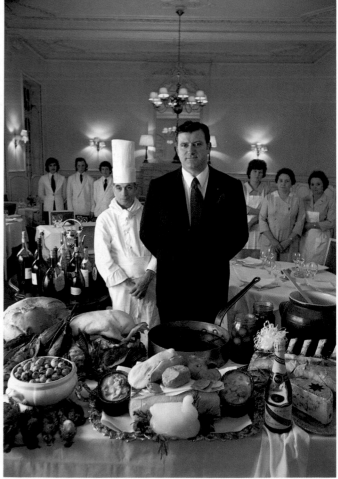

This image of scrumptious fuit tarts produced by Michel Roux was the opening shot for an article in the London Sunday Times. We put a canopy over the set to soften the light and also to protect the food in case it rained, and, of course, it did. In fact, it rained so hard that we had to cover everything for nearly an hour. By the time we were finished with the shoot, the surrounding area looked like a mud bath, but the food looked perfect. One of the tarts was actually finished on site by Michel, whom you can see in a white apron observing the set while I arrange it—I don't let anyone else do this but me.

I photographed this attractive young model in the Caribbean for an ad for Bacardi rum done by the J. Walter Thompson agency. Such assignments keep my photographic life quite exciting and are admittedly a relief after photographing five hundred cakes. Fortunately, I've had the opportunity to work in many areas other than food.

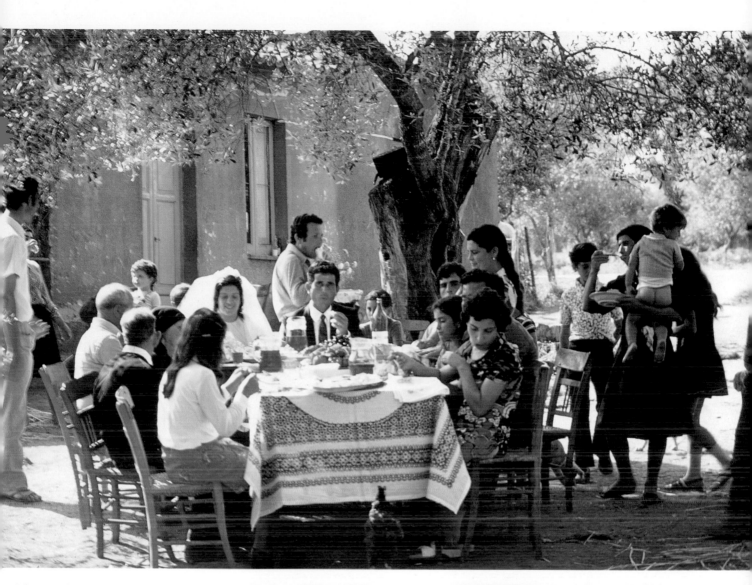

This outdoor wedding scene, set up in Calabria, Italy for an ad on Kraft cheese spreads, was not too difficult to put together, although there were chickens running around our feet and everything seemed to be going on all at once. Our biggest problem was trying to stop the people from eating the food before we took the photograph.

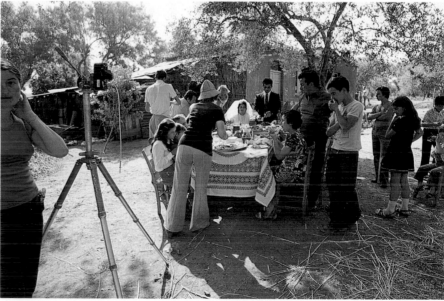

I shot several ads for a Tuborg beer campaign showing Tuborg as the evening beer of choice in the world's great cities. These pictures were taken in New York, an easy city to recognize. We set up this shot on the Brooklyn Promenade across from lower Manhattan in order to capture the skyline at sunset. I had hoped to create the final image in one shot, but it wouldn't work here. So the final image that you see in the ad consists of two 4 × 5 shots stripped together.

TUBORG. LA BIÈRE DU SOIR.

132

TUBORG. LA BIERE DU SOIR.

Another Tuborg ad was shot in Venice, where we set up the same scene on a bridge with a gondola and a barber pole in the background. Once again, I used a large white sheet as a reflector to fill in light on the people in the background. I made one shot with the sun just poking through the Tuborg glasses—it was great. But when we presented it to the client, he said, "I'm sorry, the people aren't sharp enough." This was because we had tried to do it all in one shot. So we went back and did it again in two shots that were stripped together for the final ad.

DEFINING A
PERSONAL STYLE

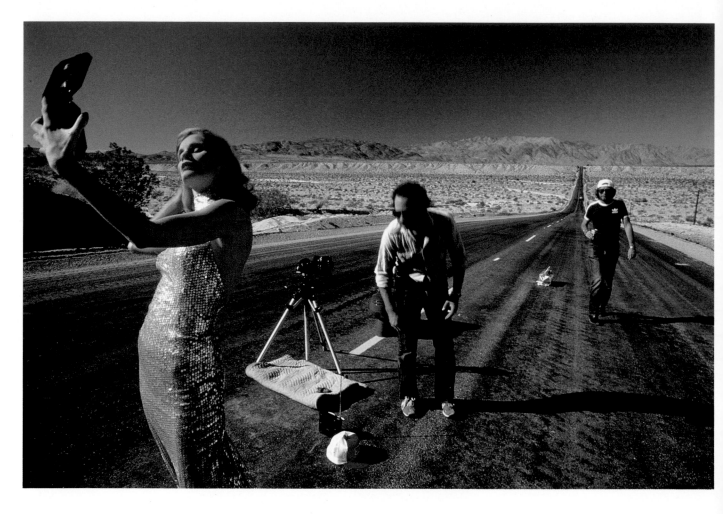

Photographers are hired for a variety of reasons; some because of their specific abilities in a particular area, others because of their talent for solving problems in any situation. Then there are those who are hired not only for their photographic talents, but also for that indefinable quality of style that they consistently bring to the assignments they undertake.

Pete Turner can easily be considered at the top of the list in the last category. Turner's advertising work is often indistinguishable from his editorial work or his "personal" pictures because of the driving aesthetic and underlying visual principles that he applies to all three photographic situations.

Obviously the situations are different. An advertising shoot on location may require that a set be built, plumbing be run, lighting be set up, or helicopters be hired. There may be a team of assistants to supervise and, of course, an art director's layout to follow. This kind of shoot is quite a contrast to the photographer venturing forth with only a loaded camera or two.

But even a cursory perusal of his book, *Pete Turner Photographs* (Abrams, 1987), quickly dispels the notion of *either/or* in Turner's work. The transitions between images made for corporate clients either on location or in the studio (or a combination of both) are seamless, and his advertising work plays compatibly off of his personal photographic statements. Both resonate, and each is irreducibly Turner.

For Turner, as with most other photographers, editorial assignments and personal shooting are synonymous. Advertising work requires stricter controls, with preplanning and preparation taking up the majority of the time spent on the shot.

However, a photographer must have a consistent vision to follow an art director's layout down to the last detail and still maintain the singular stamp of his or her own style. Certainly there are many advertising campaigns that can be photographed by almost any photographer; perhaps some do better than others, but any could do an acceptable job. However, those photographs that have the eye-stopping power—and staying power—are the ones that contain the photographer's personal touch. In all of Pete Turner's work, whether it be special effects, studio legerdemain, multiple images, or single shots, there is the unmistakable imprimatur of the photographer.

Pete Turner

Pete Turner (*Pete*, not Peter) was born in Albany, New York in 1934. His father, Don, a bandleader and saxophone player, moved his family to Montreal in 1939 where his band played at The Mount Royal Hotel, and where Pete had the run of the premises. He was an only child—with a chemistry set.

The family moved to Rochester, New York in 1945, putting young Pete in prophetic proximity to Eastman Kodak. A friend's darkroom provided the catalyst for Pete's chemistry bent to coalesce with the chemical technology of photography.

Not surprisingly, Turner entered Rochester Institute of Technology in 1952. In Turner's graduating class of 1956 were Jerry Uelsmann, Carl Chiarenza and Bruce Davidson. Photography had become, by then, legitimized in the halls of academia, but a bachelor of arts degree didn't keep Turner from being drafted.

Far from interrupting his career, the army provided both basic and advanced training in his chosen profession. By 1958, Turner knew as much about the new Type-C color printing as anyone else. He wisely amassed a portfolio of large C prints, which were catnip to art directors and picture editors. Thus armed by the army, at age 25 Turner joined the Freelance Photographers' Guild (FPG) in 1959.

After a successful New England calendar shoot, Turner was selected to document an Airstream Trailer promotional safari in Africa where he underwent a rite of passage. The resulting take was carefully managed by FPG president Arthur Brackman into an historic professional debut—spreads in *National Geographic* and *Horizon*, and medals at the New York Art Directors' Show.

Life, *Look*, *Sports Illustrated*, *Holiday*, *Playboy* and *Esquire* magazines were soon showcasing Turner's clean, spare, elegant photography. At *Esquire*, Turner met Harold Hayes, who quickly became a close friend and an enduring influence. Hayes assigned Turner a rich, non-linear range of work, a constantly surprising mix. Right from the start, Turner went his own way. He saw the '60s with uncanny acuity—the "rightness" of his imagery has lasted well past that trendy time.

Turner's virtuosity in studio technique is state of the art. I like to think of his West 57th Street atelier as "Pete's Deli," an other-worldly, sophisticated, ultra high tech, spanking-clean, digitally computerized laboratory dedicated to the making of crystalline, richly saturated filmic sandwiches. Photography is only incidentally the means of conveying the refined multi-source essences that spring from Turner's mind.

A further measure of Turner's influence is a list of some of his former assistants, including the accomplished and illustrious photographers Anthony Edgeworth, Michel Tcherevkoff, Eric Meola, Steve Krongard and Jake Rajs.

Sometimes it's interesting to look back at an advertising shot and think about all the preparation that went into the making of one advertisement. People don't realize how much goes into these things—what happens behind the scenes and how difficult it really is to make things work.

But photography of any sort is just problem solving—advertising more so than all the rest. Sometimes it's a problem I'm solving for an art director or client and sometimes it's a problem I'm solving for myself. I tackle each job differently, and I approach each job as if it were my first. Often I'll come back from a shoot with the photograph that's needed, but the assignment will raise other questions that I'll continue to work on after the job is done. Sooner or later, the problem will come up again, and I'll want to know the answer the next time around.

Location shooting is naturally the most problematic, often simply because of the logistics. I've got to find the right location, get all the crew and equipment to the site, and take care of the permissions—the actual shooting always takes much less time than the preparation. Sometimes I survey the scene after everything's all set up and think we could have done it much more easily and efficiently in the studio—but it's hard to convince clients of that during the planning stages.

The type of major production shots shown on these pages takes a lot of people to make it all work—you don't just go out there and get lucky. You not only have to work very precisely, you have to make sure that everyone else on the crew is attentive also. In the same way, the bigger the production shoot, the more you try to consolidate all the locations you need within as tight an area as possible. In that way, you're consolidating the number of people you need (various tasks aren't duplicated by local crews) and you can keep your costs down.

No matter how much you preplan, there's always a margin for error or surprise, so it's important to keep that margin down to what you absolutely can't control—in the end it makes your life much easier.

The 68 Chryslers: just add water.

CHRYSLER CORPORATION

This ad was created for Chrysler with the intent to raise public awareness about the company's marine engines. The headline was "Chrysler Motors—Just Add Water," and the art director's concept was to show boats with Chrysler engines in a desert, which is exactly what we did.

The first step was finding a desert area where my crew would be allowed to shoot. Let's face it: you don't park that many boats on a sand dune without some mutilation to the surface. A State Park in Texas gave us permission for the shoot.

Once the location was selected and secured, I became, as usual, more like a contractor than a photographer. First I had to arrange a way to haul in the boats. My crew's main concern was protecting the surface of the sand as much as possible prior to shooting. We did a layout and realized that the smaller boats should be brought in first, and then the bigger ones. The most logical method was to dig ditches, pull the boats in, trailers and all, and then fill the ditches after the boats were in position.

No matter how careful we were, the sand was still a mess, so we hired about 20 locals to rake down the area and smooth out the surface; it still looked as if Rommel's Afrika Corps had bivouacked there. Luckily, I had hired a helicopter and pilot to be on standby in case I wanted to shoot from different angles. The pilot gracefully agreed to use the chopper to blow the sand around. It worked perfectly—you'd swear those boats had been sitting on that sand dune forever. The weather was great and provided just enough wind to give us full sails. All together, the shoot took four days, including a day to pull the boats out and fill in the trenches.

I had really wanted to feature a model in this shot to give the picture a better sense of scale—either a ship's captain, a sailor with a cap, or even a pretty girl—but the agency just couldn't afford to go for the talent cost. In the end, I still feel that without the model, this could have just as easily been done as a tabletop shot in the studio.

138

139

For reasons of expense and practicality, we shot these ads for Kohler in the general vicinity of Barrego Springs, California. As you can see, there are a lot of people involved in shots with so much production, so you don't want to keep moving people and equipment around a lot—it really costs a lot and makes the shoot much more difficult to manage.

For this ad, Kohler wanted to show a railroad track. Unfortunately, there was only one track in the area where the light was right. The track itself belonged to an ore company, so we had to secure permission to work there. There was a train that went by every 45 minutes, and although we could use the track, we weren't permitted to interfere with the train's schedule. That meant the entire rigging had to be moved off the track whenever the train was due. Luckily, the train kept to its schedule, but it certainly slowed us down.

The faucets were actually in place on the track, although the final ad was heavily retouched. We went for heavy lighting on the faucets—more of a bank light approach—because of the reflections created by the tracks. I wanted this particular angle to put the afterglow of the sunset directly behind the tower of track receding in the distance. An electronic flash, fixed in the lantern, was synched with a wire that ran down the model's leg.

THE BOLD LOOK
OF **KOHLER**

At the edge of your imagination, a chance encounter yields a dazzling discovery. The Centura Faucet, available in polished chrome or 24 carat gold electroplate. For a complete, full-color catalog featuring imaginative Kohler concepts for kitchen, bath, and powder room, send one dollar to: Kohler Company, Dept. 00, Kohler, Wisconsin 53044.

This was taken at about 4:30 in the morning, at the Great Salton Sea, which is about 15 to 20 minutes away from Barrego Springs. We built the dock and started setting up to take the shot at sunrise—that meant being there well ahead of time, and having the crew out there at 2:30 AM on the day of the shoot for fine tuning.

You don't just go out and luckily take photographs such as these. The angle was picked precisely—see how the model's shadow goes right into the lens? She's blocking the light so I can have her backlit in the photograph. (This was heavily retouched for the final ad, but I personally feel that the original colors were much better. That's something you get used to.)

We started shooting at first light. It's very hard to work with the sunrise because it forces you to work against the growing light. I always prefer to work into a sunset, when I can anticipate what's going to happen; the light usually keeps getting better and better because it becomes more intense, colorful, and beautiful as time goes on. With sunrises, you have to be right on the mark because the light deteriorates as the sun gets higher in the sky.

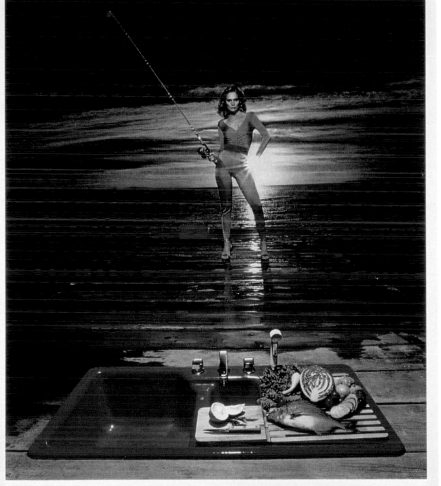

THE BOLD LOOK
OF **KOHLER**

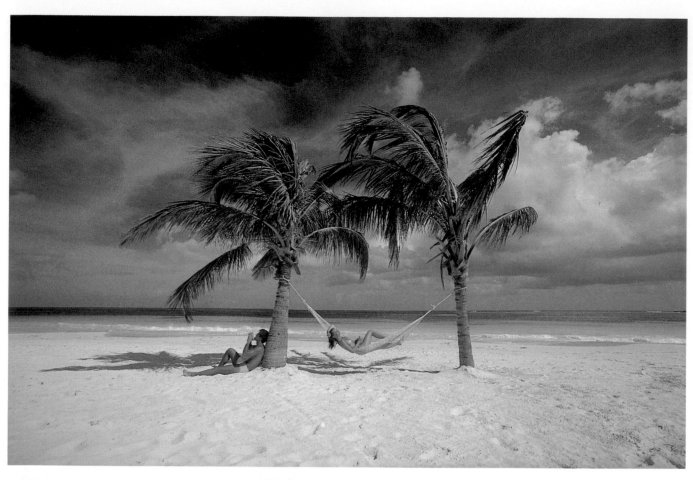

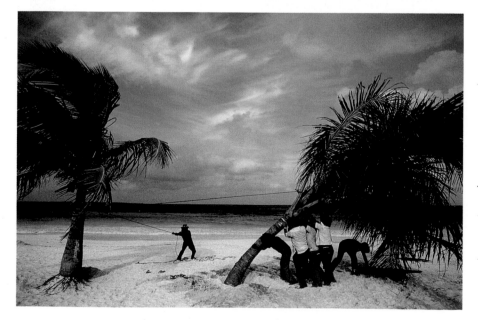

This was taken in Cancun, Mexico, for Ventana Travel, an Italian travel agency. You'd think it would be pretty easy to find two isolated palm trees to hang a hammock between; in fact, we checked every beach for hundreds of miles and they all either had great masses of trees or just one or two that were spaced wrong. Finally, we gave up looking for two trees and decided to find one tree in an area that did work, and then uproot another tree and move it into the right position.

The Mexicans who made up the local crew really had a hard time figuring out why in the world I'd want to dig up a palm tree and move it when there were so many of them all over the place. It took a lot of convincing, but they finally agreed to do the job, probably thinking, "This is some crazy gringo." By the time they finished the job, I was thinking it was a little crazy too—we found out palm trees are very hard to dig up, and just as hard to replant. It took a lot of time and we had to pay a lot of pesos, but we got the shot.

The headline for the Vantage campaign was "Performance Counts," and the color scheme was red, white, and blue. We knew we wanted to go with motion, so for the biker we used a camera car, which is an excellent way to shoot this type of subject.

Every major city has a local film industry, and they're always willing to help print people. We usually contact the various State Film Commissions to help us set up shoots because they've always been able to supply us with the names of local suppliers and good locations. In this instance, we were shooting in Denver, Colorado and hired the camera car out there.

We wanted to capture some sense of motion in each of these ads because we felt it would be a bit different; everyone had associated sharp, crisp, clean images with the client for a while, and we wanted something new. As it turned out, we were right—this campaign has been quite successful.

PERFORMANCE COUNTS.
THE THRILL OF REAL CIGARETTE TASTE IN A LOW TAR.

VANTAGE

9 mg. "tar", 0.7 mg. nicotine av. per cigarette by FTC method.

SURGEON GENERAL'S WARNING: Cigarette Smoke Contains Carbon Monoxide.

Index